Historic Tales of
COLONIAL
RHODE ISLAND

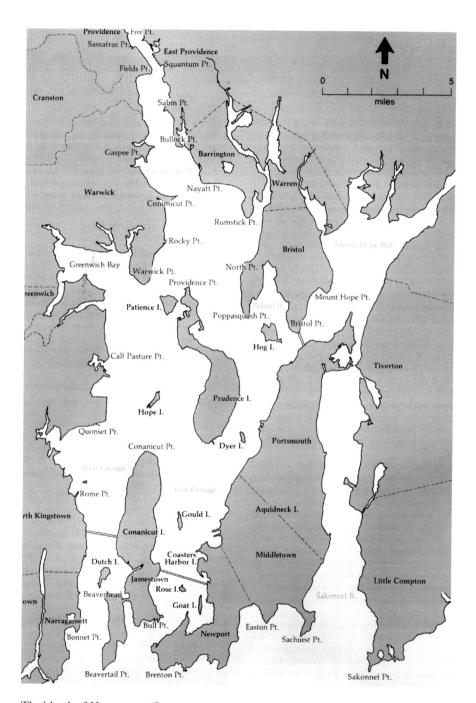

The islands of Narragansett Bay.

Historic Tales of
COLONIAL RHODE ISLAND

AQUIDNECK ISLAND AND THE FOUNDING
OF THE OCEAN STATE

RICHARD V. SIMPSON

Published by The History Press
Charleston, SC 29403
www.historypress.net

Copyright © 2012 by Richard V. Simpson
All rights reserved

Images are courtesy of the author unless otherwise noted.

First published 2012

Manufactured in the United States

ISBN 978.1.60949.911.2

Library of Congress CIP data applied for.

Notice: The information in this book is true and complete to the best of our knowledge. It is offered without guarantee on the part of the author or The History Press. The author and The History Press disclaim all liability in connection with the use of this book.

All rights reserved. No part of this book may be reproduced or transmitted in any form whatsoever without prior written permission from the publisher except in the case of brief quotations embodied in critical articles and reviews.

Contents

Preface	7
Introduction	9
1. Founding a Colony	13
2. The Rogues of Rhode Island	25
3. Captain Sir James Wallace, RN, and the HMS *Rose*	35
4. The Siege of Newport	41
5. General George Washington's Visit	53
6. Rhode Island and the Sea	61
7. Continental and Federal Navy	73
8. Historic Landmarks	95
9. The Newport Poorhouse	113
10. Architectural Resources	117
11. A Gallery of Palatial Cottages	133
12. Lifesaving and Lighthouses	141
13. A Nineteenth-Century Newport Timeline	151
Notes	167
Bibliography	171
About the Author	173

A sketch by E.B Price of the 1762 Brick Market House.

Preface

The first census taken in the Colony of Rhode Island and Providence Plantations in 1708 put the population at 7,181; of these, only about 1,000 were freemen. The military numbered 1,362 men and boys between the ages of sixteen and sixty. There was a constant drain on this armed force because the eighteenth century was a century of wars. Besides fighting the American Revolution, Britain saw combat in Queen Anne's War, King George's War, the French-Indian War and the Seven Years' War.

In 1741, the Artillery Company of Newport was founded to defend the colony against possible French attack during the so-called War of Jenkins' Ear (1739–1748).

During the mid-eighteenth century, Newport was a hotbed of intrigue, with rumors of rebellion in the air. The sympathies of Loyalists and rebels often clashed. The members of the two camps were roughly the same number, with no one group being less vocal than the other about its position. "Taxation without representation is tyranny!"—that was the war cry. According to Charles O.F. Thompson in 1947:

> *The Navigation Acts or Laws of Trade enacted prior to 1763, as far as being considered causes of the Revolution, may be dismissed; for in considering the grievances of the American colonies, the First Continual Congress confined its attention to the period of 1763 and later. It conceded that Parliament had the right to regulate colonial trade and declared that a full settlement of the controversy might be made based on a repeal of all oppressive measures enacted after 1763.*

Preface

The Stamp Act—1765, started the controversy in real earnest; it was responsible for the union of all the colonies, and their presenting a solid front for the first time.

Other grievances followed:

1767: Townshend Acts
1773: Tea Act, leading to the Boston Tea Party
1774: Boston Port Act
1774: Massachusetts Government Act
1774: Administration of Justice Act
1774: Quartering Act
1774: Quebec Act

The road leading to the American rebellion was paved with false steps and heavy-handed governance. Beginning in 1772, the Royal Navy, stationed in Narragansett Bay and Newport Harbor, endeavored to enforce and collect taxes on goods carried by swift Yankee sloops and schooners that evaded the customhouse. The British fleet felt the wrath of Rhode Islanders with the capture, scuttling or burning of several ships of the Crown, including the HMS *St. John* incident in 1764, which was the first act of open resistance, followed by the HMS *Maidstone* destruction in 1765, the HMS *Liberty* incident in 1769 and the HMS *Gaspee* affair in 1772.

Thompson continues:

In the beginning, the American Revolution was an economic struggle. Only radicals such as Sam Adams so much as thought of independence until early in the 1770s. Up to that time, the Colonists were concerned only with freedom of trade and freedom from taxes laid down by the British Parliament. True, radicals like John and Sam Adams were clutching at every straw whirling by in the maelstrom, in the hope that it could be turned to advantage for the cause of liberty. The American Revolution was fought for high ideals. The love of liberty and the hatred of the very idea of imperialism was ever in their hearts. In plain language, the American colonists did not desire to be ruled; instead, they wanted and intended to rule—this under their own independent government. This spirit sprang from the very character of the colonists themselves; this desire for a free life, one of more than a mere sufficiency, came from within—it was their very nature. They affirmed this later in their Declaration of Independence: Life, Liberty, and the pursuit of Happiness.

Introduction

The Colonization of Aquidneck Island

As an aid to the reader's understanding of the colonial settlement of Aquidneck Island, I offer this summary of how the white man came, founded the town of Newport and established the colony of Rhode Island.

In 1524, Giovanni de Verrazano sailed up Narragansett Bay and spent some time exploring Aquidneck Island and exchanging greetings with the natives who lived there. His journal contains praise for the fertile land and its handsome indigenous people. By 1614, Dutch navigators and trappers were exploring the island and trading with the natives.

When Roger Williams arrived at what is now Providence in 1636, Canonicus and Miantonomi were sachems of the peaceful, prosperous and powerful Narragansett people.

At the time, the island of *Aquednecke* (Aquidneck), later known as Rhode Island, was densely wooded from its northern extremity down to the rocky spurs that form its southern shores and run out into the ocean. Its soil was rich and its climate more mild and welcoming than that of the inland parts of the bay. Due to its position between the land of the *Soughkonnets* (Sakonnet), a branch of the Wampanoag tribe, on the mainland in the east and the home of the Narragansetts on the mainland in the west, ownership of the island was in dispute for generations, and therefore it was generally unsettled by the natives of either tribe.

INTRODUCTION

Tradition holds that a decisive battle between Narragansett warriors and the Sakonnets extended the supremacy of the Narragansetts over the island previously held by the Wampanoag nation. However, since that day, the Narragansetts, who considered it a hunting ground rather than a place of permanent habitation, sparsely settled the land.

The few Indians living on the island were under the rule of Narragansett sachem Wanamataunewit. It was fortunate for the whites that the Indians attached little value to the island; otherwise, even Roger Williams's considerable influence might have been insufficient to enable colonists to sink roots into the land.

HUTCHINSON AND CODDINGTON

In 1637, when the outspoken and charismatic Anne Hutchinson, along with her family and followers, including William Coddington, were banished from the Massachusetts Bay Colony, her friends approached Williams asking for his aid in finding a place for them to settle. Williams met with the Narragansett sachems and proposed to buy the island; the price was forty fathoms of white beads, ten cloth coats and twenty hoes.

Hutchinson was born in Alford, Lincolnshire, England, in 1591. She was a religious liberal, leading Bible meetings in her home and offering her own interpretations of the Bible. Following complaints of many ministers about the strange opinions coming from Hutchinson and her allies, the situation erupted into what became known as the Antinomian Controversy, resulting in Hutchinson's 1637 trial, conviction and banishment from the Massachusetts Bay Colony. She lived at the Pocasset settlement for a few years, but after her husband's death, her fear of Massachusetts taking over Rhode Island compelled her to move totally outside the reach of Boston. She and her family moved into the lands of Dutch colonists sometime in 1642. She settled in New Netherland near an ancient landmark called Split Rock in what would later become the Bronx, New York City.

Because of inhumane treatment of the native *Siwanoy* people by the Dutch, the natives went on a series of rampages, and in August 1643, Hutchinson and all but one of the sixteen members of her household were massacred during an attack.

Introduction

It is worthwhile to note that Hutchinson is the only woman to establish a permanent settlement in colonial America.

William Coddington was a Boston merchant and very much a man of affairs. For eight years, from the time of his arrival until the trouble arose with Hutchinson's religious philosophy, he was an assistant or member of the council or upper house of the Assembly of Massachusetts Bay. In addition, he was for two years treasurer of the colony, thereby gaining the political experience useful in founding the colonies of Portsmouth and Newport. He is characterized as a common sense and serious man. The political difficulty into which he fell is as likely to have sprung from his virtues as from his failings. He had in him a little too much of the future for Massachusetts and a little too much of the past for Rhode Island.

Coddington and several other men who had been prominent in Massachusetts, while dissenting from the particular dominant tenets, gave their assent to different but equally authoritative tenets, which they desired to put in practice in a settlement controlled by themselves.

Within a year of the first permanent white settlement on Aquidneck Island, in a place called Pocasset by the natives, on "the 7th day of the first month, 1638," the Aquidneck colonists followed the example set by the settlers of Plymouth Colony by drafting and signing the Portsmouth Compact. This document is the first of its kind that swears allegiance to no monarch:

> *We whose names are underwritten do here solemnly in the presence of Jehovah incorporate ourselves into a Bodie Politick* [sic] *and as he shall help will submit our persons lives and Estates unto our Lord Jesus Christ the King of Kings and Lord of Lords, and to all those perfect and most absolute lawes* [sic] *of his given us in his holy word of truth, to be guided and judged thereby.*[1]

Within a year of its foundation, on April 28, 1639, the following article was drawn and sworn to by the Pocasset settlers:

> *We whose hands are underwritten to propagate a Plantation in the midst of the Island or elsewhere agree it; and doe* [sic] *engage ourselves to bear equal charges, answerable to our strength and estates in common; and that our determination shall be by major voice of Judge and elders; and Judge to have a double voice.*[2]

Introduction

It is clear that all the members of the original Pocasset government took part in what may be considered a premeditated removal and transference of the Pocasset Colony to the opposite end of the island—with the idea of settling at the place they would name Newport.

The Newport Settlement

When they moved to Newport, they took with them all the colony's records up to that date. This is the reason the history of Newport must begin with the settlement at Pocasset.

At the date of their leaving, in the summer of 1639, a new government formed among the thirty-one colonists remaining. The colonists changed the settlement's name to Portsmouth.

A day or two after signing the agreement, Nicholas Easton, with his two sons, Peter and John, left Pocasset Cove and sailed around the north end of the island, coasting down the west side until they came to an island where they lodged. The next morning, they named the place Coasters Harbor Island. Later, they went on to what is now Newport and began building the first English house on the east side of present Farewell Street.

As the number of settlers grew and the village's democratic form of government became sophisticated, a general desire arose to establish a state separate from all other governments, and all their early acts tended distinctly toward that end. The first recorded suggestion of this desire is dated September 19, 1642, when the settlers agreed that a committee "should be appointed" to consult about procuring a patent for this island, its harbor islands and lands adjacent. This committee advanced a suggestion of union with the Providence settlement, which indeed it ultimately joined. Roger Williams traveled to England in the summer of 1643 to solicit a patent for the three communities (Providence Plantations, Newport and Portsmouth).

In 1647, Portsmouth was the site of the greater colony's most important legislative meeting. In May of that year, Portsmouth, Newport and Providence adopted the Charter of Providence Plantations. At that meeting, the colony incorporated the anchor as part of its official seal, and the council adapted the "laws of the Province of Providence Plantations in Narragansett Bay."

1
Founding a Colony

On April 30, 1639, Nicholas Easton and his sons, Peter and John, sailed away from the settlement called Pocasset at the north end of Aquidneck Island. They coasted southward along the west shore until they landed on a small island, which they named Coasters Harbor Island. The next day, they rowed across the narrow gut and explored that section of Aquidneck where they established the settlement of Newport.

Shortly thereafter, William Coddington and several men from Pocasset joined the Eastons. On May 15, the men held an organizing council, at which William Dyer was elected clerk of the new colony. He recorded, "It is Agreed & ordered, that the Plantacon [*sic*] now begun att [*sic*] this South west end of the Island shall be called Newport."

The harbor side of the settlement was swampy; however, the men, upon reexamining the waterfront area, declared it safe and satisfactory for developing a port. An acceptable spring of fresh water was found near the present intersection of Spring and Touro Streets. At a meeting on May 16, the record shows, "it is ordered that the Towne [*sic*] shall be built up on both sides of the spring & by the seaside Southward." Soon, building commenced on the fringe of the swamp.

Almost immediately, John Clark, Robert Jeffreys and William Dyer began laying out the plots of land and highways. Thames Street was the first planned. The founders hired Native Americans for the labor of filling in the swamp; the cost of this labor was a quantity of colorful coats and buttons. Few of today's residents realize that Thames Street is built on reclaimed land.

By the early 1700s, other streets had been laid out and developed, and wharves began poking out into the harbor, inviting ship-borne commerce.

The Antinomians[3] and other religious refugees from the Bay Colony flocked to the new colony; Quakers, Moravians, Baptists and Jews all found a haven of refuge in Newport.

In 1640, Newport and Portsmouth, which then had a population of about one thousand, united to form the Colony of Rhode Island. In 1647, the colony united with Providence. The Baptist church, established here in 1640, is the second oldest in the country (the one in Providence is older). Also in Newport, the first public school in America was opened. Supported by public subscription, it is possibly the first school in the world accessible to all.

Thames Street became the town's principal artery, and along this stretch most of Newport's merchants built their businesses. Long Wharf, in concert with other wharves, connected the town and its merchants with markets in the other colonies and the Caribbean. Newport ships were heavily committed to the Atlantic triangle trade.

What was at first an outpost of civilization became a thriving commercial port and capital of the colony.

1739–1776

The foundation of Newport's prosperity is through the establishment of the Atlantic triangle trade. The merchants of Newport became wealthy, importing molasses from the West Indies and distilling it into rum, which they exchanged in Africa for Negros, who in turn were exchanged in Barbados for more molasses—and so the vicious triangle ran.

Great profits came to Newport's merchants and ship captains until, through more molasses, more rum and more slaves, wealth accumulated. With it came fashion, function and ceremony. Before the outbreak of the Revolution, the foreign trade of Newport was greater than that of New York, and the exalted social status of its wealthy citizens was recognized not only throughout the colonies but also in the American colonies of Jamaica and Antigua.

At the beginning of the Revolution, Newport's population was slightly more than eleven thousand. The old town boasted seventeen manufactories of sperm

Aquidneck Island and the Founding of the Ocean State

oil and candles, five ropewalks, three sugar refineries, one brewery and twenty-two distilleries for the manufacture of rum—all producing valuable commodities for the slave trade. In its foreign commerce, Newport had upward of 200 ships employed; its domestic trade had the services of nearly 400 coasting vessels. In the two months of June and July 1774, 64 vessels from foreign voyages entered at the Newport Customhouse. At the same time, 132 coasting vessels and 17 engaged in whaling are listed in the customhouse registry. A regular line of packets communicated with London. There were also, at this time, at least three thousand sailors who thronged the streets of the port and easily found employment on the ships that lined its docks.

More streets were developed to accommodate the growing population. There was a road to the beach and a highway for the stages carrying passengers and mail to Providence and Boston. Before the farms of Bellevue Avenue eventually disappeared and the palaces of the barons of industry were built, other wealthy families from Boston, New York, Philadelphia and Maryland constructed their finely woodworked summer retreats along the principal streets of the town.

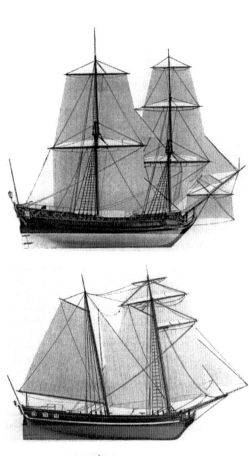

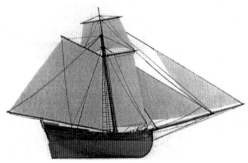

The brigantine, the schooner and the sloop were the types of ships most favored during colonial times for all kinds of maritime activities.

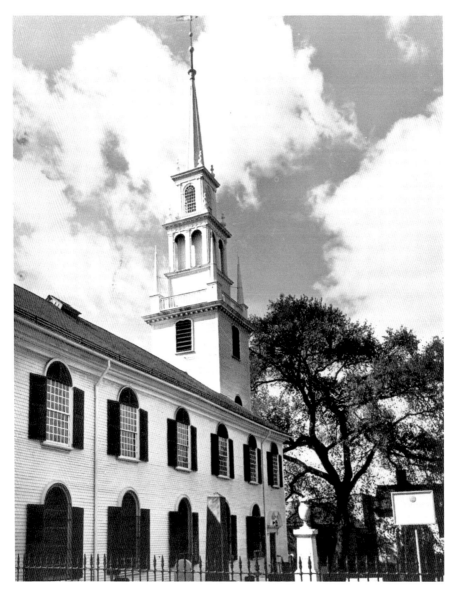

The Trinity Church on Church and Spring Streets, built in 1726, is one of the most outstanding and best-preserved churches built in colonial America. *Newport Chamber of Commerce.*

In colonial Newport, when old gentlemen of great wealth and young men aspiring to wealth in their scarlet coats, laced ruffles and cuffs, silver buckles and curled wigs, along with ladies in their rich brocades, crowded Trinity Church, they reverently knelt while the priest prayed and the sonorous

deacon, acting as their proxy, sounded the response. One portion of the old edifice, long ago removed, is the two pens in the organ loft, pierced with little funnel holes, through which the poor blacks, both free and slave, kneeling there might see without being seen.

For more than one hundred years, the town prospered in peace and plenty, until the mutterings of rebellion were heard. In 1769, six years before the Battle of Lexington, there occurred at Newport the first act of open rebellion against the Crown. Colonials from Newport seized and scuttled the HMS *Liberty* as an act of revenge for abuses perpetrated on the citizens by the ship's officers and crew.

In 1772, another outbreak occurred when some townsmen, in retaliation for British oppression, put out in whaleboats, attacking the grounded HMS *Gaspee*, the king's customs-enforcing ship. The attackers burned the ship to the waterline after removing all things of value, including its cannons. The captain, wounded in the fight, was removed to a house on Jamestown. This attack resulted in the first bloodshed in the American war for liberty and was the first armed resistance to the British navy by the colonies. After the formal rebellion began, the hardy seamen of the town, numbering about four thousand, joined to crew the ships of the fledgling American navy.

From the Battle of Lexington to the surrender at Yorktown, the men of Newport played a prominent part in all branches of the service. General Washington once complained that, owing to their hotheaded zeal, the Rhode Island troops gave him more trouble than any others, to which their commander, Colonel Olney, replied, "That is what the enemy says."

THE OCCUPATION

During the Revolution, the English and later the French occupied Newport because it was an important strategic center. This naturally killed the town's commerce. During their occupancy, the British greatly injured the town, killing livestock, polluting wells, tearing down piers for firewood and destroying nearly a thousand buildings. Trinity Church (1726) was the only important building not used as a hospital or barracks because of the crown on its spire.

In 1776, a fleet of British ships made its appearance in Newport Harbor and landed one thousand men, who were quartered in the homes of citizens. General Richard Prescott was assigned commander, and he made an

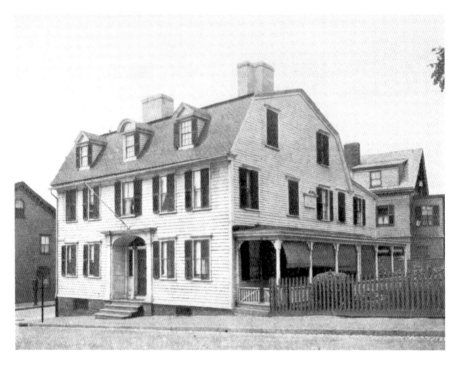

The Bannister house, on the corner of Spring and Pelham Streets—British general Richard Prescott's Newport headquarters.

imperishable name for himself as a bully and tyrant. His headquarters were the house at the corner of Spring and Pelham Streets.[4] The unpopular officer was captured during a daring mission by a detachment of Continentals under Colonel William Barton.

The long military occupation and the suppression of the slave trade reduced Newport and Rhode Island generally to poverty.

With departure of British and Hessian troops from Newport on October 25, 1779, Newport was a torpid, quiet place, its trade extinct and the streets deserted. Its wharves, which were once vocal with busy traffic, moldered away and sank out of sight under the water. Land was of no value, and the population was reduced, strangers rarely finding their way to this old, forgotten town by the sea. Houses that were once homes were deserted, weather worn, unpainted and falling to pieces. Who would then have thought of investing his money in the desolate acres that fringed the borders of this forlorn, dilapidated little village?

The Revolution seemed to have ruined Newport beyond redemption. When the British occupiers evacuated the place and the French fleet under

Aquidneck Island and the Founding of the Ocean State

Old Fort Dumplings on Jamestown, built by British engineers during the occupation of Newport.

D'Esaing entered the harbor on July 11, 1780, it was desolated. Comte de Rochambeau, a French nobleman and general, the commander in chief of the French Expeditionary Force consisting of seven thousand troops, which came to aid the American Continental army, occupied the town in a friendlier manner than the British.

During the following year, while waiting for deployment orders, Rochambeau kept his men busy restoring the fortifications and redoubts, which the British had dismantled. Claude Blanchard, commissary in chief of the French forces, left some interesting records of his impressions of Americans, as seen in Rhode Island:

> *The Americans are slow and do not decide promptly in matters of business. It is not easy for us to rely upon their promises; they love money and hard money. They do not eat soups and do not serve up ragouts at their dinners but boiled and roast and much vegetables. They drink nothing but cider and Madeira wine with water. The dessert is composed of preserved quinces and pickled sorrel. They do not take coffee immediately after dinner but it is served three or four hours after with tea. This coffee is weak and four or five cups are not equal to one of ours, so they take many of them. The tea on the contrary is very strong.*

It was at this time that the so-called Dumplings fort was built at the water's edge on Conanicut Island,[5] and construction of the original fortification, later called Fort Adams, was begun.

There is a record of the thoughts of Brissot de Warville, written on his 1788 visit to Newport, that paints a sad picture of the town at that time: "Houses falling to ruin, miserable shops; grass growing in the public square in front of the Court of Justice, rags stuffed in windows or hung upon hideous women and lean unquiet children."

Slow Recovery

Nevertheless, in the course of a few years, the business of the town had somewhat revived, and at the beginning of the nineteenth century several eminent merchants engaged in commerce there. The commercial house of Gibbs & Channing wielded what in those days was regarded as immense capital. However, the second blow that Newport received in the form of the embargo and the War of 1812 proved fatal, and from that period its commercial doom was sealed. However, not for long.

Revolution reduced the old town to the condition of a sleepy seaside village, where the greatest charm was found in its quaint old-time aspect and in the beautiful old houses, which represent the best work of colonial builders of the mid-eighteenth century.

By 1819, Newport had not completely recovered from the effects of two wars. It remained a small and struggling community, without manufacturing or industry; its citizens were dependent on the shipping that arrived from foreign ports and, to some extent, on the whaling ships that made Newport their homeport.

In 1844, only sixty-four years after British troops sailed away from Newport, this scene greeted the little squadron of yachts of the New York Yacht Club on its first club cruise. The village was then only an old-fashioned fishing town, with quaint streets and buildings and quainter denizens.

This new, friendly invasion of sail drew citizens' attention to the waterfront. Newport was rebuilding from the devastation the British had visited upon it. No palaces crowned Newport's picturesque heights; no millionaires had yet discovered its marvelous charms. The advent of the squadron was nevertheless an important epoch in the history of the town, which owes its

Aquidneck Island and the Founding of the Ocean State

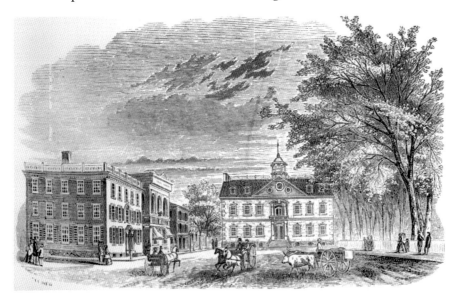

This circa 1880 woodcut of Washington Square shows the prominence of the Colony House, built in 1739.

present standing and prosperity to yachtsmen; its growth has kept pace with that of the New York Yacht Club. Much of Newport's present popularity as America's yachting capital is due in part to Commodore James Gordon Bennett, who was one of the first young men of wealth to realize the advantages of Newport Harbor and its attractiveness as a summer colony. He was a pioneer of the cottage-building frenzy soon to materialize.

How Newport rebounded is well known. Several commercial industries undertaken by astute men of wealth eager to grow stronger in affluence and influence engaged in shipbuilding, and they made great investment in provisioning ships engaged in the Atlantic slave trade and privateering against British ships harassing the newly established republic during the War of 1812.

SOPHISTICATED NEWPORT

The once rocky, desolate acres became extremely valuable to their owners. A combination of attractions exceeded the charms of other places that drew citizens for work, health and relaxation. Cooled by Atlantic breezes

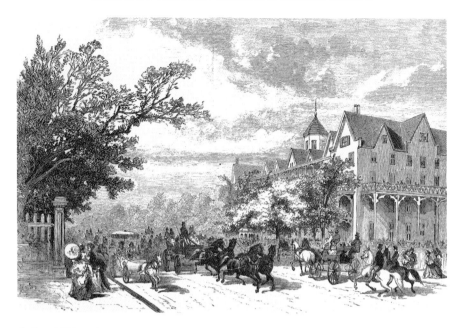

A circa 1880 steel engraving shows coaching on fashionable Bellevue Avenue.

during the heat of summer and enjoying moderate winter weather, men and women of culture and means—foreign ministers, noblemen, statesmen, authors, artists, actors and high-bred women of the old gentry—gathered here in every season, some to lead quiet, rational, domestic lives, and some to display their sophisticated manners and finery. Spacious hotels rose where fishermen's shanties once stood. The elegant steamers of the Fall River Line disembark their passengers, and smaller sail craft plied up and down the harbor and coast along Narragansett Bay. Belleview Avenue was a whirl of splendid horse-drawn carriages, and grand ladies promenaded on the arms of equally well-turned-out gentlemen.

By the mid-eighteenth century, Newport was flourishing, its swelling prosperity due largely to its maritime ventures. Merchant ship owners engaged in various avenues of commerce, not the least of which were smuggling and the importation of slaves. These enterprising merchants built their homes and counting houses close to the waterfront, where they could overlook their cargo sheds, wharves and the comings and goings of their ships.

In the mid-nineteenth century, Newport ushered in its so-called Gilded Age. Of all the American colonies, Newport was unusually cosmopolitan. As in the earlier century, Newport welcomed Jewish and Quaker traders

who were frowned upon in other settlements. Wealthy visitors from southern plantations came to escape the heat and pestilence and happily fraternized with the fashionable elite of Newport society. Some of the very wealthy—the rubber, coal and railroad barons—stayed and built marble palaces. Their cottages were elegant summer houses constructed of the finest materials, challenging the most grand of European palaces. They incorporated every variety of architecture—baronial splendor in Swiss, Gothic, French, Elizabethan and American. They lined the spacious avenues, nestled between the forest of mature elm, oak and chestnut or clung to the rocky cliffs overlooking the ocean.

When the chill of autumn drove those summer residents back to their city homes, the old town reposed into its winter sleep—though not as profound a slumber as it enjoyed during the years of British occupation. There is always work to be done in preparation for the next onslaught of visitors.

2
THE ROGUES OF RHODE ISLAND

Taking a ship on the High Seas...from the possession or control of those who are lawfully entitled.
—Definition of "piracy" under English law

PIRATES AND PRIVATEERS

During the protracted war of the late seventeenth century between France and England, the colony of Rhode Island began its first experience in naval warfare. According to Welcome Arnold Greene in *Providence Plantations* (1886):

> *Many privateers were fitted out, probably mostly from the island, though citizens of Providence served in them. The actions of some of these privateers were claimed to be too broad for even the loose notions of the laws of privateering then extant, and our bay furnishing peculiar facilities as a resort for those rovers of the sea, the Colony then obtained the unenviable reputation, which it retained long after any occasion for it had gone by, of being a "nest of pirates."*

Throughout Rhode Island's long colonial period and early years of statehood, certain seekers of fortune signed aboard vessels where no

questions were asked and no wages given. Crews worked for a share of profits, often obtained illegally. These seamen are the privateers, buccaneers, free-booters, corsairs and, of course, pirates of legend. The much-heralded privateer turned pirate Captain William Kidd found refuge for a time in Rhode Island.

During the late seventeenth century, many towns along the East Coast of North America were ports of refuge for pirates. They would bring their ill-gotten goods to these towns and, with their armed ships lying off the defenseless shores, would command them and place the settlers at their mercy.

Rhode Island Colony was known widely as the port that tolerated the most smuggling in North America. In Rhode Island, the public's "wink and nod" at the craft of piracy and smuggling became so well known that the Crown threatened to withdraw the colony's charter. Because of the threat, many pirates met their finish at the end of a rope, but smuggling continued unabated.

Rhode Island's reputation was seriously sullied by allegations that it offered a safe refuge for pirates. Lord Bellomont, the gout-ridden governor of Massachusetts, New Hampshire and New York, charged, "The government of Rhode Island is notoriously faulty in countenancing and harboring of pirates, who have openly brought in and disposed of their [ill-gotten] effects there, whereby the place has been greatly enriched."

It is true that the colony of Rhode Island (the town of Newport in particular) did gain in prosperity in both money and goods. Historians who study the pirate culture point out that piracy would not exist if it were not for the support of the public. During Rhode Island's colonial era, pirates and privateers provided struggling settlers with quality goods at low cost. Unintimidated, these raiders of the sea would come ashore and always find persons ready to afford them opportunities for debauchery at which to spend their money. Always welcome, hard money in gold and silver coinage flowed liberally from the money pouches of the free-spending "gentlemen of fortune."

In 1653, a scant seventeen years after Roger Williams established his colony in Providence, he wrote *Letters of Marque and Reprisal*[6] for Captains John Underhill, William Dyer, Edward Hull and Thomas Baxter to prey on Dutch ships and other enemies of the Commonwealth of England. Newport's court of trials, under the governorship of William Coddington, granted the privateer commissions.

A certain captain accused of piracy in the late seventeenth century with a Rhode Island connection is Captain John Avery, known to his peers as

Aquidneck Island and the Founding of the Ocean State

"Long Ben." In February 1697, some of Avery's crew men were captured and put on trial in London. To gain the court's favor for clemency, Avery fingered several comrades he knew as Rhode Island pirates. The English Board of Trade issued the charge that "several informations [sic] have been transmitted to us, wherein mention is made of Rhode Island, as a place where pirates are ordinarily too kindly entertained."

Governor Samuel Cranston denied the charges and called Avery a liar.

A story, with the scent of fact, is of a roughneck sailor taken into custody and dragged to court, charged with being a pirate. When the judge asked for his plea, the man said he was guilty. The judge, thinking the man insane for admitting to being a pirate, dismissed the charge and set him free.

In his 1881 book, *Picturesque Rhode Island*, author Wilfred H. Munro writes about one particularly successful Rhode Island pirate:

> *When a mere lad* [Godfrey Malborne] *ran away to sea, and was not heard from for many a year. About the beginning of the last century* [eighteenth], *he settled in Newport, and soon became the most noted of all its merchant princes. Dark and full of mystery are some of the tales that are told concerning him. His ventures upon the sea seem to have been unusually lawless, even for that lawless age, and the fair fame of the city in which he dwelt suffered in consequence.*
>
> *During the French war, which began in 1744, Newport sent forth more than a score of privateers. The Frenchmen called the town a "nursery of corsairs," and planned its capture. "Perhaps we had better burn it as a pernicious hole, from the number of privateers there fitted out, as dangerous in peace as in war," wrote one officer to his superior in rank.*
>
> *Smuggling, Malborne of course indulged in. It was hardly deemed discreditable to anyone, not at all to be censured if he who engaged in it happened to be a man of wealth. Persons now living[7] have seen upon the estate Malborne once owned, the entrance to an underground passage, which afforded easy communication with the beach, and thus enabled him to elude the vigilance of the customhouse officers.*
>
> *It is said that his "corsairs" preyed upon both Spanish and Frenchman with an impartial disregard for treaties; and it is a well-established fact that large sums of money were recovered from him in England by legal process, for the spoliations he systematically practiced upon the Dutch.*
>
> *In 1745, two of his privateers, large and beautiful vessels, fresh from the stocks, sailed out of the harbor on the day before Christmas, bound for the Spanish Main. A violent snowstorm came up, and the gale soon changed*

to a hurricane. Newport had two hundred widows in consequence, for the ships were never heard of afterward.

When a Rhode Island privateer returned to Newport or Providence from a successful cruise, his fellow colonists honored him as a hero, but when a Frenchman of the same trade fell into their hands, he was apt to suffer the penalty for piracy. According to Edward Mayhew Bacon in *Narragansett Bay* (1904):

> *The mildest-mannered man that ever scuttled ship or cut a throat might have found his prototype on board a Rhode Island privateer, or one from the Bay colony, commanded by a Presbyterian elder or a Quaker legislator, and manned by crews that had been nourished on the shorter catechism and who handled their sheets to the accompaniment of a "chanty" from the Psalms of David.*
>
> *Their nets were cast for fish of all varieties. A plate[8] ship, bowling home from the Spanish Main, a slaver bringing its sorry passengers from the Congo Coast, or a merchantman freighted with the handicraft of weavers and smiths of France were alike welcome to the devout freebooters.*
>
> *It was a profession to tempt the ambition of restless youth, and its prizes were not infrequently greater than could be won in any other.*

Captain William Kidd,[9] a Scotsman and family man residing in the city of New York, was a respected, bold and skillful shipmaster sailing out of Manhattan. His reputation for honesty placed him so high in the esteem of well-established New York merchants that he was granted a letter of marque and hired by British merchants, Governor Lord Bellomont among them, to cruise against pirates who were raiding their vessels. It is alleged that Kidd, in turn, smelling easy money, turned to the pirate's craft.

It is also alleged that Kidd obtained much of his great wealth off the coast of Madagascar in the Indian Ocean in 1697–98. The methods he used to accumulate his fortune are subject to some disagreement among historians.

In the spring of 1699, Kidd, now a fugitive for his supposed acts of piracy, sailed his ship, the *San Antonio*, into Narragansett Bay, dropped anchor off Conanicut (Jamestown) Island, sent a small boat ashore and invited his old Rhode Island corsair friend Captain Thomas Paine for a visit aboard the sloop.

Kidd asked Paine to take care of his loot while he sailed up to Boston to see the governor about the charges against him. Later, Paine wrote to the

Aquidneck Island and the Founding of the Ocean State

governor that he cut loose from his old ways and would have nothing to do with Kidd's plunder.

According to the popular, oft-repeated legend, leaving Conanicut Island, Kidd sailed to Gardiner's Island in Long Island Sound, where he buried chests of treasure. After securing his treasure, Kidd then proceeded to Boston, where Governor Lord Bellomont betrayed him. He was securely chained, thrown into a cell and later taken to England. There, he was tried for piracy and murder, found guilty and, in 1701, with nine of his crew, hanged on Execution Dock.[10]

The following quote is from an article, "Rogues, Rascals & Pillars of Society: Pirates—Part VI," that appeared in *Old Rhode Island* magazine in August 1994:

> *Despite the fact that Bellomont was one of the men responsible for sending Kidd to the Indian Ocean, Kidd approached the American colonies along the Atlantic coast with caution. He apparently had taken much of his wealth with him and this is when many believe Kidd buried his treasure in a number of locations as a safeguard against arrest and treachery. According to E.R. Snow, Kidd sailed around Long Island and anchored at Oyster Bay where he was joined by his wife and children.*
>
> *Kidd then sailed into Narragansett Bay to confer with Captain Thomas Paine at Jamestown* [Conanicut Island].
>
> *Kidd's sloop the* St. Antonio, *carrying 10 guns, sailed into the East Passage of Narragansett Bay, called Rhode Island Harbour at the time. According to Rhode Island historian Samuel Greene Arnold, the British cabinet issued orders to the governors of all colonies to apprehend the "notorious Capt. Kidd should he appear in their waters." Samuel Cranston, then governor of Rhode Island, acting upon these orders sent his tax collector with 30-armed men to board the* St. Antonio.
>
> *When the authorities approached the* St. Antonio, *Kidd fired two shots from his large cannons and the collectors withdrew. Kidd then proceeded to Jamestown to meet with Captain Thomas Paine. It was rumored that at this time Kidd turned over a lot of gold to Captain Paine.*
>
> *The proof of this and of the friendship between Paine and Kidd comes from a letter dated July 18, 1699, written by Sarah Kidd, the Captain's wife, to Captain Paine. Mrs. Kidd asks Paine to deliver gold to a man named Andrew Knott for Kidd's defense following his arrest.*

The bulk of Kidd's fortune has never been found. Treasure hunters have searched in vain for many years. Besides Gardiner's Island, other supposed sites of the buried treasure include Conanicut Island (Jamestown) and Block Island.

When Paine died—at home in his bed—he was buried in the family graveyard to the rear of his house. His headstone bore the inscription: "Thomas Paine Mate to Captain William Kidd."

The following text from *Picturesque Rhode Island* tells of the taking of a pirate ship in Rhode Island Sound by William and John Wanton and their crew of young adventurers sometime in 1701:

> *A piratical ship, of three hundred tons, mounting twenty cannon, appeared off the harbor of Newport, cruising between Block Island and Point Judith, interrupting every vessel that attempted to pass, capturing property, and treating the officers and crews with great severity.*
>
> *To remove an annoyance so injurious to the comfort and prosperity of the inhabitants of Newport, two young men, William and John Wanton, sons of the first Edward* [Edward Wanton Sr. of Tiverton] *determined to attempt to capture, and the means they resorted to were as novel as the success was glorious.*
>
> *No sooner had they made known their intention than about thirty young men of their acquaintance joined them, and a sloop of thirty tons was engaged for the enterprise. The brave fellows went on board with only their small arms to defend themselves, and sailed out of the harbor, apparently on a little coasting excursion, every person being concealed below except the few required to navigate the vessel. After cruising a few days they espied the object of their search. As they drew near the piratical vessel, with the intention, apparently, to pass, the pirate fired a shot at them. This is what they desired, in order to give them an opportunity to approach the pirate. The sloop immediately lowered the peak of her mainsail and luffed up for the pirate, but instead of going alongside, they came directly under her stern.*
>
> *Her men at once sprang upon deck, and with irons prepared for the purpose grappled the sloop to the ship and wedged her rudder to the sternpost to render it unmanageable. Having so far succeeded in their purpose without alarming the piratical crew, or leading them to suppose they were approached by anything but a little coaster, each man seized his musket, and taking deliberate aim, shot every pirate as he appeared on deck. After making great efforts to disengage themselves, and finding it impossible, the*

Aquidneck Island and the Founding of the Ocean State

rest surrendered, and were taken into the harbor of Newport by their brave and gallant captors, and turned over to the authorities, where, after a trial, they suffered the penalty of their crimes by being hanged.

When the affair took place, William Wanton was but twenty-four and John twenty-two years of age.[11]

Building Newport's first fort prevented the ever-present cadre of pirates from entering inner Newport Harbor, but for many years, they continued to make the Rhode Island coast and Narragansett Bay islands their anchorage. Such piratical lawlessness continued until 1723, when there was a bold encounter by two pirate sloops, the *Ranger* and the *Fortune*, with the British sloop of war HMS *Greyhound*. The warlike ships were cruising in company and harassing friendly shipping along the coast of the southern colonies. They sailed northward in search of more profitable cruising grounds and at last attacked what they thought was a rich merchant ship. It proved to be His Britannic Majesty's sloop of war the *Greyhound*, mounting twenty guns. One of the marauders made its escape; the other was not so fortunate. The ship was captured with its remaining crew of thirty-six men—those who survived the deadly action. Shackled, they were taken to Newport and tried there, and twenty-six of them were sentenced to hang. The twenty-six were hanged on July 19, 1723, and buried without ceremony near the execution site "within the flux and reflux of the sea" at Gravelly Point, on Goat Island.

The names of these pirates were Charles Harris, Thomas Linniear, David Hyde, Stephen Mundon, Abraham Lacey, Edward Lawson, John Tompkins, Francis Laughton, John Fitzgerald, William Studfield, Own Rice, William Read, William Blades, Thomas Hugget, Peter Cures, William Jones, Edward Eaton, John Brown, James Sprinkly, Joseph Sound, Charles Church, John Waters, Thomas Powell, Joseph Libby, Thomas Hazel and John Bright.

In 1738, the French privateers Pierre Legrand, Pierre Jesseau and François Bondeau were convicted of piracy and hanged at Newport.

Records show that as late as 1760, four more pirates were tried in Newport, convicted, hanged at Easton's Beach and buried between high and low water on Goat Island.

Privateers

Even in times of peace, vessels were overhauled and plundered by French and Spanish privateers, as was the case of the fifty-ton Rhode Island sloop the *Virgin Queen*; with a crew of six men, it was sailing to Jamaica in 1727. Its captain, Robert Brin, recorded:

> *Upon the Holy Evangelists of Almighty God that on the 19th day of this Instant September being in the latitude of 33 & 10 North he met with a Spanish Ship who with her launch and thirty-two men armed rowed up with the said sloop and took her and carried her along side of said Spanish ship which carried twenty four Guns and was manned with one hundred and Eighty Men and called the* Holy Trinity. *Joseph Roderigo, Master who took out of the said Sloop the Greatest Part of her Cargoe, The particulars whereof are mostly contained in the annexed account and put Eleven English Prisoners (which They had in said Ship) on board the said Sloop. And this said Robert Brin told the said Joseph Roderigo that it was Peace at Home but he replied he had a Commission from the Governor of the Havanna to take all English Vessels and after they had detained ye said Sloop for about the Space of six Hours and took All Their Mens Cloaths they dismissed her. Whereby he was obliged to make the best of his Way for this Port in order to refit where he Yesterday in ye afternoon.*

Not always, when captured, were the vessels allowed to return home, as was the case of the *Sea Nymph*, eighty-five tons and with a crew of nine men, bound for Rhode island with 5,400 gallons of molasses, 2,500 pounds of sugar, 300 pounds of cocoa, one pipe of Madeira wine, one Negro boy and 300 heavy pieces of eight.

In 1730, the *Sea Nymph* captain, Samuel Wickham, told a sad tale of being taken by a Spanish privateer. He said that on the eighth day of September,

> *as he was coming thru the Windward Passage he was taken by a Spanish privateer or pirate commanded by on Faridino, who carried the said Samuel Wickham his sloop and company into a small harbour at the North East part of the Island of Cuba where they in a piratical manner destroyed and threw overboard all the said Cargo of Molasses, Sugar and Wine excepting a small Matter they kept for their own Use after which they unrigged their own Vessel and sunk her having put all their Meat, Guns, Small Arms, ammunition on board the said Sloop* Sea Nymph *filling her*

for their piratical Use and then sails with her into the Harbor of Basacon, where they stay'd three or four Days and then put out to Sea with the said Wickham and his company on board, when they carried to Windward so far as the Island of Tortugas where they took a Small English Sloop bound from Providence for Jamaica and then set the said Sloops company, the said Samuel Wickham and five of his men ashore on a Desert Island called the Caucos first taking from them their Cloths, Wattches, Money, and everything of Value on which Island he remain'd a Month, two or three Days before they were taken off said Island.

In 1731, Governor Jenkes reported that Rhode Island Colony had two ships, a few brigs and many sloops, amounting to five hundred tons and manned by four hundred seamen, trading largely with Boston, though a few with England, Holland and the Mediterranean and ten or twelve with the West Indies. "The amount of shipping, it will be noticed, is increasing."

Rhode Island had reason to be proud of the successes of its privateers. Over eighty letters of marque and reprisal to capture vessels and merchandise of enemies of the king of England were issued by Rhode Island in King George's War and over sixty letters in the French and Indian War. The average vessel size was 115 tons, ranging from the *Virgin Queen* at 33 tons and the ship *London* at 390 tons.

The crews shared the spoils. The potential bounty shared by the crew of a successful voyage incited each man to his best endeavor, so the share of the privateer sailor put him on his mettle. Moreover, the Crown allowed a bounty of five pounds for each man on a captured enemy vessel.

It is true that great returns were uncertain, but this added spice to the adventure. When common seamen received £5,000 each, as in the case of the seamen of the *Revenge* out of Newport, recruiting crews was an easy matter. The captured vessels were taken to the nearest British admiralty court and, if judged legally captured, were condemned and sold with their cargoes. The proceeds were divided among the owners, officers and crew. As Rhode Island vessels usually intercepted West India trade, the cargoes captured were rum, molasses and sugar. Sometimes wine, cotton or dry goods and occasionally silver pieces of eight were also captured.

So successful were Newport privateers that a French pamphleteer declared that the town of Newport should be destroyed, as it was a menace to French commerce.

3
CAPTAIN SIR JAMES WALLACE, RN, AND THE HMS *ROSE*

The terror that lay in Newport Harbor, feared by all marine interests in Narragansett Bay during the colony's occupation by the British, was the HMS *Rose*. The secret of its infamous reputation is its captain, one of the most colorful figures in eighteenth-century Newport: Sir James Wallace, RN.

The following text by William H. Drohan is his undated, unpublished monograph titled "Cousin Wallace":

> *Captain Wallace had been serving on the American station under Samuel Graves, Vice Admiral of the* [HMS] White *and was due for rotation when a series of events began that, for Wallace, would mean a permanent place in Rhode Island history.*
>
> *The British forces found themselves surrounded in Boston, and the Royal Navy was dispatched to the major ports to prevent the importation of arms, and to secure supplies for the besieged city. It was hoped that the presence of a royal warship would discourage the newly aggressive colonials. With this in mind, Captain Wallace sailed to his assigned post, the royal fort in Newport Harbor. The result was predictable; the Rhode Islanders, armed with little more than rhetoric and enthusiasm, were at first very impressed with the threat that a warship in their waters presented. However, Wallace had been assigned a vast area to patrol and when his ship was cruising, Rhode Island quickly regained her courage. Returning from one such cruise, Wallace found that the Royal Fort on Goat Island had been entered and*

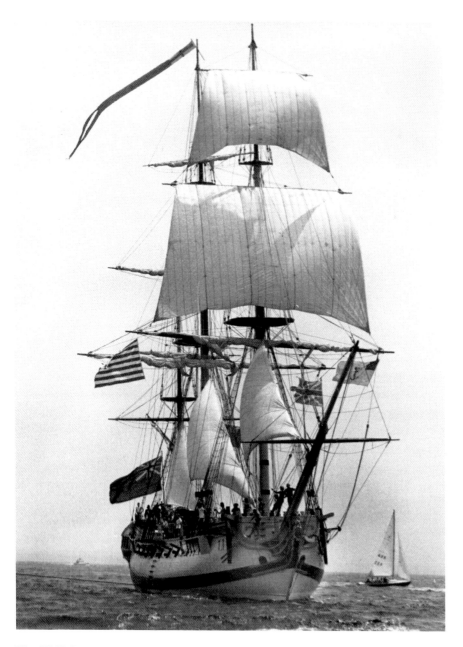

The HMS *Rose* replica sails on Narragansett Bay, circa 1970. Notice the plethora of period flags.

Aquidneck Island and the Founding of the Ocean State

stripped of its cannon. This was too much of an insult for the Crown to bear, and Captain Wallace notified the Governor of the colony that the guns must be returned immediately. The answer from Providence, "There are no guns here," sent the captain into a fury. It was true, there were no guns in the Governor's [Nicholas Cooke, 1775–78] *office, there were no cannons in the fort either, and cannons do not disappear unassisted.*

Secure in his cabin, Captain Wallace reflected upon the situation. There had been other incidents in this troublesome colony involving the HMS Liberty *and the HMS* Gaspee. *Both indicated that Rhode Islanders were capable of anything. Captain Wallace had received a lesson in Rhode Island strategy but, like shylock, he was determined to better the instruction. In the next few years, he would more than avenge his humiliation, earning the esteem of Admiral Graves, who was to send him additional ships, and the hatred of the locals who referred to him as "Cousin Wallace."*

Among his achievements were raids on Bristol, Fall River and a number of other rebel strongholds, the disruption of trade throughout the colony, even as far as New London, Connecticut, to confiscate numerous cargoes to supply the Boston garrison, interception of the post riders, personal insults and a constant fear of the destruction of Newport. These actions, while harsh, had some justification in civil control and late the prosecution of war for Rhode Island was very active in securing powder and arms, and raised both troops and a navy to oppose Britain. Wallace was resourceful and long commanded the strongest ship in the area, but he realized his limitations. He could not be everywhere, he did not know the local channels and shoals, and despite a superior ship, it was still a small force, far from assistance.

Faced with an impossible situation, he took Newport for his base and effectively commanded the front door of Rhode Island waters. The city was a logical choice, well situated and defensible. It was the best port in the area, the royal fort was there, and the city has the largest concentration of loyalists in the colony. These supporters of the Crown must have been small comfort for each[12] *other as even Captain Wallace, when dining with his friends ashore, was subject to insult and threat, and more than once returned to the* Rose *looking over his shoulder.*

Despite his problems, Wallace patrolled, seized, threatened, and managed to hold Newport for the Crown. His reputation grew, and soon he was not only being given a wide berth by rebels, but was being sought out by isolated loyalists. From Washington's camp at Cambridge a loyalist sent information to the Rose's *captain with a young woman who revealed the scheme. Wallace also supplied arms to Thomas Gilbert for an abortive*

Historic Tales of Colonial Rhode Island

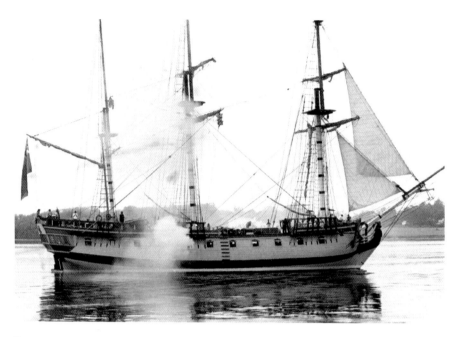

June 1987, the HMS *Rose* fires a broadside in Bristol Harbor. *Bristol Phoenix* photo.

attempt at counter-revolution in Freetown [Massachusetts]. *Admiral Graves was pleased with the exertions of his captain, and at the first opportunity set additional ships under his command.*

Contemporary accounts paint Wallace as foul tempered at best, and near mad when aroused. These authors, despite first-hand information and experience in the midst of the Revolution, could hardly be expected to speak well of the most visible manifestation of British control and such an effective enemy. Captain Wallace may have been rather brusque but he was a clever, hard working commander, who lost no opportunity to harass the rebels or thwart their efforts. He was one of the most successful and aggressive captains of Admiral Graves' thin blockade, and his works were largely responsible for the British hold on the area lasting into 1778.

Much of this man's story had been lost to history, but what remains tells an absorbing tale of secret meetings, desperate plans, raids, battles, and intrigues and a major role in our Revolutionary War history cannot be denied to Cousin Wallace.

Aquidneck Island and the Founding of the Ocean State

THE HMS *ROSE*

The quiet of a lazy mid-summer afternoon is broken by the boom of a cannon fired from a nine-pounder aboard His Majesty's twenty-gun frigate the *Rose*. From 1774 until its departure in 1778, the *Rose*'s daily salute to the Crown was a ritual imposed on Newport colonists.

As Rhode Islanders, we remember that the Rhode Island Charter, issued by King Charles more than a century before the Revolution, granted many freedoms that were not extended to any other British colony. For instance, the colony's governor was not appointed by the monarch but elected by the landed gentry. It is thought that because the area was so small it hardly existed on any regional map, a general spirit of tolerance existed in the colony. Because of this tolerance, during the first half of the eighteenth century, piracy and smuggling thrived here.

In 1774, the frigate *Rose*, under Captain Sir James Wallace's command, arrived in Narragansett Bay. Its duty was to put an end to the piracy and smuggling that had made Newport the fourth-wealthiest city in America. Since the *Rose* was much larger than any American vessel of the time, and Wallace an effective commander, piracy soon came almost to a standstill, but smuggling continued as a most lucrative business among Rhode Island's ship captains. The HMS *Rose*'s activities, in attempting the suppression of smuggling in the colony of Rhode Island, provoked the formation of what became the Continental navy, precursor of the modern United States Navy.

The suppression of smuggling severely affected the economy of Newport. Rhode Island's merchants petitioned the colonial general assembly to create a navy to deal with Wallace. They backed up their petitions with money by fitting out the merchant vessel *Katy* for naval service. This vessel was commissioned as the sloop of war *Providence*, which became the first naval command of John Paul Jones.

Wallace, accepting his obligation to assist customs agents, established a blockade, pursuing and stopping ships suspected of smuggling. Wallace was also obliged to support the welfare of the men of his fleet: the *Glasgow* (sister ship of the *Rose*), the sixteen-gun *Swan*, the brigantine *Bolton* and several support vessels, the crews of which numbered about five hundred.

Rhode Island colonists quickly realized Wallace's vulnerability—he needed food for his crews. Because their fortunes were at stake with the loss of their smuggling enterprise, citizens began planning actions against the despised blockaders.

Farmers began driving their stock to farms remote from Newport. By the fall of 1775, Newport was in essence deserted; citizens had left the town, taking with them all their possessions, including livestock.

This drove Wallace to raid other seaside farming communities in southern New England. To his regret, opposition against him and the *Rose* raged all along the coast.

Newporters began an operation of harassing Wallace's fleet by firing on his ships with cannons dragged to strategic points around the harbor. Before troops could be mustered to find the cannons, they had vanished, only to reappear and fire on the ships from a different direction. In order to protect his ships, Wallace was forced to continually shift his moorings.

With the formation of the Colonial Navy of Rhode Island and the lack of provisions to feed his five hundred men, Wallace was forced to sail his little fleet from Narragansett Bay in June 1778 in favor of Halifax, where the ships were overhauled and quickly sent to New York.

4
The Siege of Newport

August 1778

From the outbreak of the war, France had sympathized with America in its struggle for independence. In February 1778, it signed the treaty of alliance. It gave us aid and sent us officers and troops. After the surrender of Burgoyne, France recognized the United States as an independent power.

The Lay of the Land

To aid the reader unfamiliar with the topography of Aquidneck Island and its environs, some description of the eighteenth-century battleground on which the episodes of the siege of Newport and the Butt's Hill struggle (described below) took place are offered.

Near where the Sakonnet River and railroad bridges cross to Aquidneck Island, Howland's Ferry once spanned the Sakonnet passage. The upper portion of the island, narrow and rising into hills—Butts, Turkey, Anthony's and Quaker's—pear like in shape, grows in breadth until some dozen miles below. Its southerly line fronts on the sea. Sachuest Beach, near the Sakonnet passage, and Easton's Beach, near the town of Newport in coves opening to the south, are separated by a rounded peninsula known as Easton's Point. At the end of the beach, near the town, the shore takes a

new direction toward the southwest along the cliffs (now lined with elegant mansions), then in pastures accessible by country lanes guarded by gates. These cliffs reach their southerly point near a boathouse, and then the shore winds for several miles in an easterly direction by bays and headlands to the Beaver Tail channel by Brenton's Point, separating Rhode Island Colony from Conanicut. Conanicut, nine miles in length, but of no great breadth, forms the west shore of the middle channel, the main avenue for navigation from the sea to Newport Harbor, three miles from Beaver Tail light at its entrance. It is now guarded by Fort Adams (in 1778, forts and bastions protected it), rendering it difficult to access by hostile fleets. Outside Conanicut spreads the west channel of Narragansett Bay with its wide mouth to the ocean, extending down to Point Judith. This bay, with Rhode Island on the east, Narragansett shore and Warwick on the west and the islands of Conanicut, Patience and Prudence in its middle, extends some thirty miles to the Providence River. Between Rhode Island and the main land opens the east passage, which washes the east shore of the island. Of no great width but deep for navigation, it sweeps down to where Cundall's Mill once stood, passes Fogland Ferry to Little Compton and heads along Indian Avenue and Third Beach to Sachuest Point on the sea, near the bathing beach called Sachuest.

Some two miles back from the bathing beach rises Honyman's Hill, with a gradual slope of about two hundred feet; it skirts toward the sea guarded by Easton's Pond. A lagoon was flooded five feet deep, reaching down nearly to the sands of Easton's Pond. While the flooded lagoon shielded the town and formed part of its defenses, it also served to protect the left flank of the Americans on Honyman's Hill. The outer British lines were from the bathing beach to Coddington Cove on the west side of the island, above Tamany Hill, protected in their center on Bliss Hill, half a mile from Honyman's Hill. The town on the western slope toward the harbor was guarded on the north by Tamany, a natural fortress. The British lay beyond the reach of American artillery.

On the main road, two miles from the town, stood a smithy's forge at the fork of the east and west road. Diverging, the two roads[13] traversed either side of the island. About four miles above the fork, these two roads reconnected by a crossroad above the former residence of Dr. Channing. This fork in the two principal roads was originally proposed as the center of the American position during the siege. It was important to outflank the British left at Coddington Cove and keep open these roads for retreat if the safety of the army became endangered. Above the fork, at Slate Hill,

Livingston and Jackson opposed the British advance the morning of the battle, and on the crossroad, four miles above the fork, Wade cut down a large portion of Colonel Campbell's regiment.

This general view will make more intelligible the operations of the twenty days described below and illustrate why Honyman's Hill was occupied and why the attack was not made from the southwest against Newport, as proposed by D'Estaing.

The French Arrive

The French fleet arrived off Brenton's Ledge, three miles below Newport, on July 29. They were in need of water, bread and vegetables to cure scurvy. General John Sullivan,[14] with whom the admiral had already exchanged letters, went on board the *Languedoe* the next day, and plans were resolved for future operations. The first proposal was that the French should land at Tower Hill, in forty flatboats provided for the purpose, and at least a feigned attack in that quarter seems to have been under consideration. The southwestern corner of the island, extending from Easton's Cove to the Beaver Tail channel, over which Fort Adams stands guard, was then a thinly forested wilderness and pastures, and had the fleet been of sufficient strength without the Americans to attack it, the place was more vulnerable on that side than from the north. D'Estaing disembarked a number of his men suffering from dysentery on this shore near Brenton's Point.

What was finally agreed was that, under cover of the guns of the main fleet, the French should land on Conanicut and cross over near Dyer's Island to the west shore, about five miles from the town, while the Americans crossed the east passage near Cundall's Mill or at Fogland Ferry, thus cutting off three British regiments at Butt's Hill. To cover their crossing, the *Alemène* and the *Aimable*, under command of St. Cosme, under whom served DeGrasse, had entered the East Passage on July 30. Upon their appearance, the *Kingfisher*, the *Spitfire* and the *Lamb* were set on fire. The *Sagittaire* and the *Fantasque* entered the west channel on August 5, getting the weather gage of two British frigates that were also burnt.

D'Estaing proposed to remain off Beaver Tail until the American troops arrived from New York and other New England colonies. Meanwhile, the

Sagittaire and the *Fantasque* moved quickly up the west channel to intercept two Hessian regiments on Conanicut, but upon approach, these regiments withdrew.

On August 7, the admiral, growing impatient at the delay of the troops, proposed to land without waiting for the army, and on the next day, with eight ships, he forced the middle passage and moored them in front of the town behind Rose and Goat Islands. Immediately, the British scuttled or burned the *Grand Duke* and their remaining ships and appeared in great alarm.

That same day, Sullivan received an eagerly expected contingent of troops from Boston, and learning that the British had evacuated Butt's Hill, he issued his general orders to cross the Sakonnet River the next morning. Lafayette's troops remained at Tiverton until the afternoon; a parlay with D'Estaing would assure him of their cooperation with his troops.

Lafayette joined D'Estaing with intelligence of the current situation. The admiral was already disembarking his troops onto Conanicut, part already ashore and part in boats, when Howe's fleet hove into sight off Point Judith. The troops were quickly recalled, and D'Estaing, thinking both Lord Howe and Lord Byron might be there, began arranging his ships for whatever might come his way.

When morning broke, the north wind blowing and the tide surging, D'Estaing forced again the middle channel under a heavy fire, losing sixty men, and went to sea in pursuit. In the evening of August 11, as they were coming to an engagement, a hurricane of extraordinary violence burst upon them. It was all that the French or British ships could do to escape catastrophe. That night, the vessels of both squadrons were unmanageable and in constant danger of collision or foundering. The *Languedoe* and the *Tounant* lost their masts. Both fleets received damage and dispersed.

The *Preston* attacked the *Languedoe* and the *Renown* attacked the *Tounant*, but both were beaten off. The *Vaillant* took the bomb brig *Thunder*; on August 15, the *Hector* battled the *Senegal*. The *Cèsar* fought the sixty-four-gun *Iris* but, after doing it damage, was prevented from taking it by two other vessels coming to its relief. The French vessel lost seventy killed and one hundred wounded; among the latter was a captain who lost an arm.

On August 20, D'Estaing, who had promised to return, made good on his promise by coming on shore near the east channel, only to inform Sullivan that in the shattered condition of his fleet, he must sail to Boston to refit. The admiral made his way to Boston, passing through a channel between Nantucket and the banks, while being followed by Lord Howe for a time before returning to New York.

Aquidneck Island and the Founding of the Ocean State

From the American Perspective

When the first fleet, under Count d'Estaing, sent by France to our assistance reached the country, it was hoped that by its aid the British might be dislodged from Newport.

When the French ships entered Narragansett Bay, all of Rhode Island was elated. General Sullivan was in command of the Rhode Island department. Half the men of the state were called into service; our neighbors in Massachusetts, Connecticut and New Hampshire sent militia to our assistance. General Washington sent two brigades. General Varnum and General Glover sent regiments from the Continental army and placed them under the command of General Lafayette, who would also serve as a liaison officer with the French. As a last and crowning contribution, Washington sent to our aid that ever-reliable son of Rhode Island, General Nathanael Greene.

Plans for a simultaneous landing of the French and Americans on the island of Rhode Island were perfected for July 10, 1778. The troops from the French fleet were to land on the western side of Rhode Island, while the Americans landed on the eastern side. Against this combined force, the British and Hessian troops in Newport, under General Pigott, unless reinforced from New York, could not hope to hold out for long.

Nevertheless, the enemy prepared for battle by withdrawing the troops from Conanicut and from the northern end of the island within the lines of Newport and laid waste to the surrounding country, filling wells and removing cattle and all tools that might prove helpful to our forces. All seemed favorable for our success, but in a moment, everything changed. Even as D'Estaing's forces were entering their boats to land for a practice drill on Conanicut, the July fog lifted and disclosed a British fleet off the mouth of Newport Harbor. Though General Sullivan, seeing the Butt's Hill fort on the commanding heights of Portsmouth evacuated, had hurriedly ferried across troops from Tiverton and sent to D'Estaing for assistance, the French commander considered it necessary to sail out and meet the English fleet. The hurricane mentioned above blew the fleets out to sea and prevented an engagement. When the storm was over, the French admiral returned, only to report the damaged condition of his ships and the necessity of sailing to Boston for repairs.

Meanwhile, Sullivan, though crippled by the departure of the French fleet, had moved down the island and besieged Newport, but many of his volunteers, demoralized by the storm, melted away.

Sullivan invited his generals to express in writing what course of action they considered best under the circumstances. Greene and the majority advised pressing the siege and, if the weather permitted and enough volunteers remained to warrant it, sending a few hundred men from Sachuest Beach by boat to land on the cliffs, south of the town. The force, working its way in the fog and dark, might take by surprise the fort built around a red house commanding the bathing beach. If successful, signals along the line with false attacks would create confusion, while several thousand men sweeping across the bathing beach would scale the cliffs.

Three trusty men from New Hampshire sent by Sullivan as scouts, after killing one man and wounding two, were taken prisoner. The other preliminary conditions of the sham attack did not appear; the garrison redoubled its vigilance, and the army numbered about 5,400.

Sullivan dispatched Lafayette to D'Estaing at Boston, beseeching him to send down his troops to the north end of the island. The siege was pressed, apparently with unabated vigor, while preparations went on for removal.

Sullivan, after besieging the British in Newport, hesitated to venture on an assault because of the demoralized condition of his army and the lack of the expected cooperation from the French fleet. At ten o'clock on the night of August 28, he quietly withdrew the main part of the army with every article of war to Butt's Hill, which the men reached at two o'clock. They rested there against the probabilities of the coming day.

At dawn, the British sentinels discovered the withdrawal of the Americans from their front. Word was sent at once to Pigott. They could not be sure that what was unusual might not indicate some covert attack. Generals Prescott and Brown occupied the abandoned earthworks. Smith, with the Forty-second and Forty-third and flank companies of the Twenty-second and Fifty-fourth, was dispatched up the east road. Losberg, with the Hessian chasseurs, Anspachers of Voit and Seaboth, went up the west. The former were soon after reinforced by the Fifty-fourth and Hessian regiments of Huya, and the latter by Fanning's provincials. Pigott, in a supply wagon with an aid, directed these movements from the main road. The reinforcements sent to Smith found the road to Quaker's Hill blocked. Wigglesworth did not arrive until Smith had gained his position on the summit.

Sullivan sent Colonel Henry B. Livingston, with Jackson's regiment and other troops forming one light corps, to Windmill Hill to protect the front of his army. Another force under John Laurens, with Henry and Talbot, proceeded to the west road for the same purpose, in their rear at the crossroads, about three miles in advance of his position at Butt's Hill, with

the picket of the army in support. Two regiments were sent to reinforce them, with orders to keep up a retreating fire and to fall back slowly. At seven o'clock, with the British columns advancing, a series of skirmishes ensued. Reports on the action indicate the earliest important conflict took place at Windmill Hill, but probably Slate Hill is more accurate. Livingston, with his command, resisted the attack of Smith with vigor and persistence, as it was not designed to bring on a general engagement there. Livingston, after inflicting much loss on the enemy, drew back, content with harassing Smith's further progress. Smith pressed on to encounter Wigglesworth and Sprout, of Glover's brigade, on Quaker Hill.

Major Talbot, six miles from Newport, charged on the Hessian cavalry and drove them back. John Laurens, conspicuous in white and green, on a noble charger and in command of a regiment of Continentals in buff and blue, as well as other troops, attacked the enemy wherever opportunity offered, pouring bullets down on them from every stone wall and knoll. He took possession in turn of a line of forts along the west shore, and the Hessian Malberg described him as impeding their progress and repelling their attacks with success until outnumbered. When in danger of being surrounded and cut off, Laurens withdrew, fighting as he went to the main army.

The heavy losses inflicted on a British column in the crossroad above the Gibbs place then changed. In a field butting on that road to the south, on the east road and an intermediate road parallel with the east road, Wade had placed in ambush part of the picket. The Twenty-second, Colonel Campbell's regiment, advancing up the east road, turned into the crossroad. When least expected, the Americans leapt from behind their cover, pouring a storm of bullets into the faces of the astonished foe, and before they had recovered from their surprise, another volley cut down one-quarter of their number. Malberg mentions in his report several other skirmishes that took place in the early morning, the area of the coal mine being the scene of some strife.

General Greene, in council with his officers, advised a general attack on the divided enemy before reinforcements arrived. After consultation, he concurred with the majority that it was wiser to hold the strong position occupied.

While reconnoitering, Greene stopped at Anthony's for breakfast, his guards on watch in nearby woods. One of the sentries gave alarm to the general that the foe was at hand; seemingly unperturbed, he calmly finished his eggs, leaped into the saddle and quickly regained the lines.

As Smith reached the base of Quaker's Hill, he found Colonel Wigglesworth and Colonel Sprout's regiment from Glover's brigade and

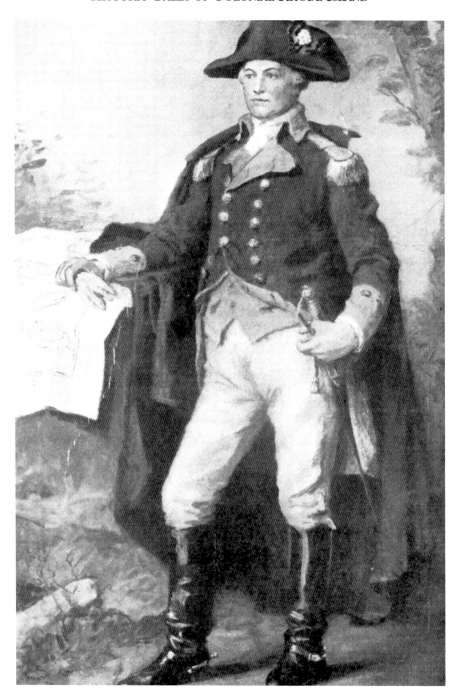

Portrait of General Nathanael Greene, by Gari Melchers. The painting is in the State Reception Room of the Rhode Island Capitol.

Aquidneck Island and the Founding of the Ocean State

another on his right under Colonel William Livingston from Varnum's drawn up to suppress his ascent. He sent word to Pigott that the enemy was there in force.

Smith was twice repulsed, and many of his men were captured. Orders came to draw back; this withdrawal occurred with great order and regularity. Thinking the Americans intended to cross to the Tiverton fort, Smith pushed on, looking for some favorable opportunity to attack their rear guard.

Sullivan's decision had already been made to draw them onto the ground that he had selected nearer Butt's Hill, and for this purpose, his baggage train and wagons had been marshaled toward the ferry. The advanced troops, as ordered, disputed the ground and fell back to the main army. Smith, still pushing on as Wigglesworth withdrew, encountered Glover's whole brigade with the guns and fell back behind the lines of Quaker's Hill, which, with Turkey and Anthony Hills surmounted by strong bastions, the British army occupied. The Hessians were under Losberg on Anthony.

About a mile or so from this line of hills, beyond a valley interspersed with clumps of trees, groves of thickets and meadows, rose to the north the slopes of Butts, about two hundred feet in elevation, surmounted by a fort. In front of the works was drawn up the first line of Americans commanded by Greene, who had under him that day his cousin Christopher and Varnum, Glover and Cornell as brigadiers. The second line lay in rear of the hill. The reserve, half a mile back near a creek, held the ferry—all important should disaster, or Clinton's fleet, hourly expected, make it prudent to cross. The artillery and stores collected were too precious to be endangered. The corps of Livingston and Jackson and all who had taken part in the morning battles were stationed behind the hill to sleep off their fatigue and be ready when required. The left, commanded by Lovell, extended westward from the Sakonnet River; it consisted partly of militia from Massachusetts who had fought bravely in the critical stages of the battle. Its artillery drove Smith back toward evening in his last effort to regain the advantage. On the extreme right of the front line, near Narragansett Bay, a fort was garrisoned by a regiment armed with heavy guns to beat off ships that might attack from the water or molest their crossing if that became an object.

South was the ground and such the dispositions of the two armies when, at nine o'clock, the battle began. The prime objective of the enemy was to capture the fort that commanded the approach by water, as two of the three ships that had arrived on Thursday with smaller vessels were ordered up, and soon after they came in sight. While awaiting their arrival, the British showed no inclination to precipitate the conflict. At nine o'clock, a gun from

their right opened the battle; its echoes were lost in the continual roar of artillery, as both sides engaged in the cannonade. Skirmishers were thrown out from either army to little purpose, until the British and Hessians swept in great force, and with quick movement, down the slopes of Anthony, hoping to capture the redoubt. The American right stayed their progress by their well-aimed and destructive volleys; the ground was heaped with the dead and wounded as, in a disordered, chaotic and helpless rout, they fell back. Veterans in war, they soon responded to the call of their leaders and resumed their ranks as they regained their lines.

The Combatants Regroup

Enraged at their unexpected loss of composure, the British and their allies rested for a few brief moments to recover from their fatigue before renewing the conflict. Speedily reorganized and reinforced, their principal strength, with more prudent caution and steady step, again descended the hill. Their guns behind them protected their march until they reached the valley, when the shell and shot of their opponents rent their ranks, disturbing their formation and impeding their progress. Filling the gaps, they pressed on to avenge their fallen comrades and soon reached the foot of Butt's Hill, upon whose heights were the four brigades of Greene.

The British and Hessians—professional combatants disciplined in training—deployed as they advanced, fired and reloaded, unmoved by the missiles from the batteries or the showers of bullets from American muskets. Enveloped in smoke, their aim was not effective.

The Americans, familiar with the ground and guided by the discharge flash of the enemy's weapon, with every volley swept down scores of their assailants. The day was warm; shut in between the hills, no breeze could reach them. The heavy uniforms of the Hessian grenadiers and British infantry inhibited their movements. The Americans, discarding every garment that could impair their efficiency, made every shot lethal. The officers kept well in control of their several commands, a task less difficult for troops holding their lines and partially protected.

Some moments were lost in consultation and transmission of orders by the enemy, who had become somewhat demoralized by being exposed to this wholesale slaughter, but when orders reached them to charge up the

hill, up they rushed with dauntless fearlessness. Mowed down again by the guns, shriveled at each step, they confronted sturdy Yankee farmers, inured by hardships and exposure, who met without flinching these professional soldiers. It was a desperate struggle for supremacy. Both sides lost heavily; the brigade of the gallant Varnum, most exposed, lost the largest number.

Neither Sullivan nor his generals forgot that the fort by the bay was the key to their position, and the enemy never forgot that to take it was their objective.

The British endeavored to press to the left along the lines of Greene, hoping to cripple him as they went and reach the bastion, but found in their front an obstinate resistance. Losberg, when supposing the approach to the fort comparatively open, pushed his Hessians, sure of capturing it. The fort's two batteries, engaged in beating off the ships, still renewing their effort to silence them, kept them employed. Some portion of his troops reached the vicinity of the fort with formidable threat. As other Hessians came down to join the rest, two battalions of emancipated slaves and Indians posted in the thickets awaited their approach, and as they came within range, four hundred sharpshooters poured in their fire. The Hessians faltered. Shattered and bewildered, they turned and fled, leaving behind many dead and wounded.

Tradition tells us that the Hessians continually charged only to be repulsed each time, sacrificing many lives in the attempt to overpower the defenders.

Meanwhile, Sullivan, with his staff, watched the progress of the battle from his hill, guiding and directing its operations.

As Losberg with the Hessians was pressing hard on Crane, and Smith strove to disengage his broken ranks from Greene, a regiment of Continentals, held in reserve for such an occasion, frustrated Losberg's purpose and reinforced the water battery, covering as well the space between it and Greene's right.

Colonel Henry B. Livingston and his light corps, composed in part of Jackson's regiment, resting behind the hill, exhausted by a sleepless night and their morning combats, were deaf to the roar of the guns. Roused from their slumber, they preceded around the hill to watch for their chance to take the enemy at disadvantage and drive them from the field. Piggott, observing his army in danger of defeat, collected his reserves to have at the ready when needed. Lovell and the second line advancing held these reserves in check until Livingston, following, virtually closed the fight.

The anticipated opportunity came. Greene, relieved of the pressure in his front, advanced four regiments, crowding his enemy in the meadow, who became more and more disorganized away from any base of operations and without support. Livingston bided his time. At the most propitious moment,

he led Jackson's regiment at double-quick pace, with bayonets fixed fiercely on the foe; taken by surprise, wounded and exhausted, the enemy made such resistance as they could. They soon gave way, and the whole company of combatants was swept across the field and up the slopes of Quaker's Hill until they found shelter behind their lines. The Americans captured soldiers on the hill as they went, as well as one battery, seized as a trophy of their charge and triumph.

The panic spread. Losberg led his Hessians back to Anthony, his foes in hot pursuit; the rest of the British army moved with speed and confusion to their entrenchments. Losberg later wrote that the battle ended at 4:00 p.m. Pigott wrote in his report that toward evening, with the Chasseurs being advanced and in danger of being cut off from the British left, he sent Fanning and Hays to their relief, who, after a smart engagement, obliged them to retreat to their main body on Windmill Hill.

Of this operation, Colonel Trumbull said that toward evening he was ordered to take Lovell's brigade of Massachusetts militia "to aid in repulsing a body of the Germans pressing our right. When they gained the ground, no enemy was seen; they were overmatched by our troops and had retired from the field of combat." This best-fought battle of the war between 5,000 on both sides and lasting nearly twelve hours, in which the enemy was driven from the field at the point of the bayonet with the loss of 1,023 men, was more than the skirmish Pigott had predicted.

The next night, under cover of darkness, Sullivan withdrew his victorious army unmolested to the mainland at Tiverton.

In its well-contested fight, with the consequences involved, it ranks among the most important battles of the struggle for independence. The struggle at Butt's Hill, known as the Battle of Rhode Island, erupted from the failed siege of Newport. It is the only battle fought on Rhode Island soil between the Continental forces and British troops.

5
GENERAL GEORGE WASHINGTON'S VISIT

This chapter is a reproduction of text included in a forty-page booklet titled George Washington and Rhode Island, *issued as a souvenir by the State of Rhode Island in 1932 on the occasion of the bicentennial year of Washington's birth.*

George Washington came to Rhode Island four times; on his third visit in 1781, he was welcomed to Newport in grand style. Many stirring events had transpired since his previous visit in 1776, when he stopped over in Providence for two nights and enjoyed the hospitality offered by citizens, who entertained him in a manner befitting his honored position in the hearts and minds of American Patriots.

WASHINGTON MEETS ROCHAMBEAU

On March 6, 1781, three months before the French army departed from Newport for Yorktown, General Washington visited Count de Rochambeau to consult with him concerning the operation of the troops under his command and to hasten the sailing of the expedition under M. Destouches, who had resumed direction of the fleet after the death of Admiral de Ternay, whose untimely death had occurred in Newport several months before. Washington journeyed toward Newport on horseback as far as the old South Ferry, about a mile to the south of what is now Saunderstown,

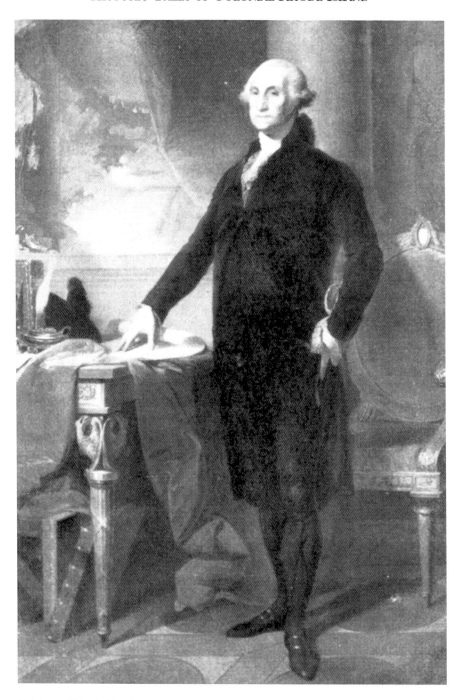

Celebrated Rhode Island artist Gilbert Stuart painted this portrait of President Washington; it hangs in the State Reception Room of the Rhode Island Capitol.

Aquidneck Island and the Founding of the Ocean State

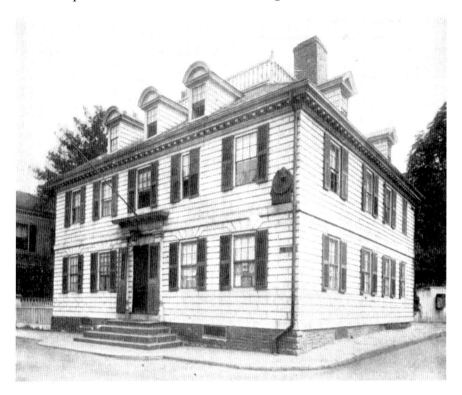

Count de Rochambeau made Vernon House, on the corner of Clarke and Mary Streets, his headquarters during the French occupation of Newport. General Washington visited Rochambeau here in 1781.

reaching his destination by way of the Conanicut Ferry. A resident of South Kingstown recorded in his diary that the general had passed through that section about ten o'clock on the same date and that he was accompanied by about twenty soldiers acting as guards. On his way across the harbor, he stopped to exchange greetings with the French generals who were assembled on board the *Duc de Bourgogne*, and in the early part of the afternoon, he was taken by barge to the landing, where he stepped ashore amid the plaudits of the admiring throng. The French fleet, lying at anchor in the harbor, fired a salute, and the army, numbering nearly seven thousand men, was lined up in a double rank on both sides of the street extending all the way from the landing point to the old statehouse on Washington Square. Passing through this imposing guard of honor, Washington proceeded first to the statehouse, where he was received officially, and then continued on to the Vernon House, at the corner of Clarke and Mary Streets, Rochambeau's headquarters, where Washington was to be the French general's guest.

Washington, Marshal of France

An eyewitness of this historic procession through the streets of Newport records his impressions of the scene as follows:

> *I never felt the solid earth tremble under me before. The firing from the French ships that lined the harbor was tremendous; it was one continued roar, and it looked as though the very Bay was on fire. Washington, as you know, was a marshal of France; he could not command the French army without being invested with that title. He wore, on this day, the insignia of his office, and was received with all the honors due to one in that capacity. It is known that many of the flowers of the French nobility were numbered in the army that acted in our defense. Never will that scene be erased from my memory. The attitudes of the nobles, their deep obeisance, the lifting of hats and caps, the waving of standards, the sea of plumes, the long line of French soldiers and the general disposition of their arms, unique to us, separating to the right and left, the Chief, with Count Rochambeau on his left,* [with hats in hands], *walked through. The French nobles, commanders, and their under officers, followed in the rear. Count Rochambeau was a small, keen-looking man, not handsome, as was his son, afterwards* [the] *Governor of Martinique. Count Noailles looked like what he was—a great man. But the resplendent beauty of the two Viosminels eclipsed all the rest. They were brothers, and one of them a General in the army, who had the title of Count, too. Newport never saw anything so handsome as these two brothers.*

This same observant citizen continues:

> *But we, the populace, were the only ones that looked at them, for the eye of every Frenchman was directed to Washington. Calm and unmoved by all the honors that surrounded him,* [neither] *the voice of adulation nor the din of battle had ever disturbed the equanimity of his deportment. Ever dignified, he wore on this day the same saint-like expression that always characterized him. There were other officers of inferior grade too that followed, and I afterwards saw them on horseback, but they did not sit on a horse like Washington. The roofs and windows of every house in sight were filled with the fair part of creation; and Oh! the fluttering of handkerchiefs and the showing of favors. It was a proud day for Newport.*

Newport Entertains Washington

On the evening of the same day that Washington arrived in Newport, the buildings in the town and the ships in the harbor were brilliantly illuminated. The town council asked the citizens to purchase candles for the illumination and requested that every house, large and small, should show a light. An evening parade through the principal streets featured the program of festivities on the day of arrival, and it is recorded that a group of boys bearing candles attached on long sticks headed the procession. Washington appeared in the line, accompanied by Rochambeau and other officers, their aides and a great company of citizens. The evening was clear, and there was not a breath of air to fan the torches. The marchers passed through the principal streets and finally returned to headquarters in the Vernon House. This treasured structure is still standing today, in an excellent state of preservation, and is occupied by the Family Welfare Society (circa 1930), an important social service agency in Newport.

Washington Dances with Peggy Champlain

Washington thoroughly enjoyed the company of charming ladies, and he had an opportunity to meet and admire the fairest of the fair among the social lights of Newport's fashionable circles at an elaborate ball held in his honor in Mrs. Cowley's assembly room, which then stood on Church Street. Both the American and French officers had frequented this popular rendezvous quite often during the preceding winter, and Washington found the place, the occasion and the guests most agreeable. The guest of honor opened the ball with Miss Margaret (Peggy) Champlain, noted for her beauty, charm and grace and who selected the dance "A Successful Campaign," whereupon several of the French officers seized the instruments from the musicians and played for the general and his fascinating partner. The soft light from the silver candelabra was reflected in beautiful mirrors loaned from local mansions, and the gay party danced and promenaded beneath festoons of bunting looped with rosettes of swords and pistols.

 A continuous round of social functions, and very likely many unavoidable conferences, occupied Washington's days and evenings in

Newport until he took leave of his friends and colleagues on March 13 and journeyed overland to Providence. On his departure, the French saluted him with thirteen guns, and again the troops were drawn up in line in his honor. Count de Rochambeau escorted Washington for some distance out of town, and Count Dumas, with several other officers of the French army, accompanied him to Providence. They passed through Bristol, Warren and Barrington, and a stop was made at Warren, where the general and his suite dined in the tavern of Shubael Burr, whose bill for entertaining amounted to £12.12, which the item was later ordered paid by the [Rhode Island] General Assembly. Count Dumas described the scene in Providence when the group arrived as follows:

> *The whole population had assembled from the suburbs; a crowd of children carrying torches, reiterating the acclamations of the citizens, surrounded us; all were eager to approach the person of him whom they called their father, and pressed so closely around us that they hindered us from proceeding. General Washington was much affected, stopped a few moments and pressing my hand said, "We may be beaten by the English; it is the chance of war; but behold an army which they can never conquer."*

WASHINGTON'S FOURTH RHODE ISLAND VISIT

George Washington visited Rhode Island for the fourth and last time in 1790, when the smallest of the states finally ratified the Constitution. When the general became president of the young republic, which he had brought into being, he decided to make a complete tour of the entire territory composing the United States. In the autumn of his first presidential year, he started this plan by visiting New England between October 15 and November 13, 1789, omitting Rhode Island since it had not fallen in line with all the other states and come into the Union. However, when Washington received word that the last of the thirteen colonies had joined with the others in May 1790, he acknowledged the ratification as follows:

> *Since the Bond of Union is now complete, and we once more consider ourselves as one family, it is much to be hoped that reproaches will cease and prejudices be done away; If we mean to support the liberty and*

Aquidneck Island and the Founding of the Ocean State

independence, which it has cost us much blood and treasure to establish, we must drive away the demon of party spirit and local reproach.

Upon the adjournment of Congress, August 12, 1790, Washington made immediate arrangements to visit Rhode Island, and he left New York City for that destination on Sunday, August 15, going first to Newport by boat. He was accompanied by Thomas Jefferson, secretary of state; Georg Clinton, governor of New York; Theodore Foster, senator from Rhode Island; Judge Blair, of the United States Court; William Smith, member of Congress from South Carolina; Mr. Gilman, member of Congress from New Hampshire; and three gentlemen of his official family. This was the only sea voyage ever recorded by Washington, except the trip to the Barbados in the fall of 1751, when he accompanied his ill brother Lawrence, who sought to regain his health in a warmer climate.

WASHINGTON'S LAST APPEARANCE IN NEWPORT

The people of Newport, where he remained for a day and a night, received Washington with great enthusiasm. A huge throng greeted him at the wharf; he received many official salutes, and a long procession marched through the streets in his honor. He took a walk about the town, and the day ended with a dinner at the statehouse, which was filled to overflowing with the enthusiastic and admiring populace. On the next day, August 18, the president departed for Providence after he had participated in a program of exercises, which included addresses by prominent citizens and by the honored guest himself.

The trip from Newport to Providence must have been a tedious one since the passage required seven hours, but the well-planned reception that awaited him at the head of the bay very likely banished all irritation caused by the lengthy boat ride and the late arrival. Two days previous, the town had prepared to give Washington an official reception. The leading citizens of the community held a public meeting "to consider of the most proper measures to show the veneration the Town hath of his Character and the Sentiments of Gratitude the Inhabitants entertain for his rescuing America from the prospect of Slavery and establishing the Liberty upon the broad basis of Justice and Equity under a Constitution the Admiration and Envy of the civilized World."

Among the things at this meeting, it was voted to have all the windows in the Market House mended to help the appearances of the business section, and Henry Ward, Dr. Enos Hitchcock, Welcome Arnold, David Howell and Benjamin Bourne were elected on a special committee to prepare an address to be presented to the president. Another committee was appointed to arrange the details of the official reception, and all the inhabitants were requested to clean sidewalks and streets adjoining their dwellings and have everything spic and span before noon of the day when Washington was expected to arrive. At a second meeting on the following day, the wording of the address prepared by the special committee was approved, and Daniel Stillwell was ordered "to cause the State House to be handsomely illuminated on Occasion of the Arrival of the President of the United States."

6
Rhode Island and the Sea

Newport

During the early eighteenth century, vessels were generally those of Newporters trading with the West Indies. Only occasionally was there a ship heading to London or Liverpool and some to Madeira. According to Governor Cranston, cargoes were usually lumber and corn gathered from other colonies; horses; some oil; candles; provisions; sheep and cheese, onions and geese from Bristol; beef, flour and bread from Narragansett Bay; and fish from Newfoundland.

The report of the vessels detained in Newport Harbor in 1755 to prevent provisions and intelligence from reaching the French at Cape Breton was the character of the commerce of this period. Bound for Barbados were the sloop *Hannah*, with 120 sheep and one hundred geese; the sloop *Leopard*, with 2 casks of rice, forty pounds of beef and pork and twenty barrels of flour; and the bark *Maggot*, with forty barrels of beef and pork, 60 sheep and seven firkins of butter. The sloop *Molly* sailed for Jamaica with thirty barrels of flour, 80 sheep and five barrels of rum, and the sloop *Herring* carried forty barrels of flower, 20 sheep, three tons of bread, five hundred weight of cheese, 20 casks of rice and one hundred geese. Headed for Africa, the sloop *Penguin* carried 120 casks of flour, beef, pork and butter.

The lading for these outward voyages was in many cases not the produce of Rhode Island but the result of previous trading with neighboring

colonies; thus, the lumber came from Connecticut, West Jersey and New Hampshire, sometimes in the rough and sometimes already manufactured in staves, hoops and barrelheads. Pitch and tar came from North Carolina, while wheat and Indian corn were brought from Virginia.

During the early colonial period, whaling came into prominence, and in 1723, the general treasurer's accounts show payment of £171 for 433 pounds of whalebone and two and a half tons of oil. In 1731, the colony offered a bounty of five shillings a barrel on whale oil and a penny a pound on whalebone for ten years; in 1738, the colony renewed the bounty for another ten years.

In 1733, the sloop *Pelican*, owned by Benjamin Thurston of Newport, brought in 114 barrels of oil and 200 pounds of bone. The *Pelican* was the first regularly equipped whaler of Rhode Island. For the years 1733 to 1738, the general treasurer's books record payments for 1,211 barrels of oil and 3,843 pounds of whalebone. According to the *Providence Town Records*:

> *We see the last farewells said on the wharf at Newport, the lines are cast off, and the ship speeds away from the cold gray shores to the happy azure waves of southern seas, marked by long yellow lines of floating gulf weed torn from the Sargassa [sic] Sea, the play of flying fish and dolphins around the ship.*
>
> *Anon a hostile vessel appears, guns flash and roar, but seldom is the conflict severe. The smoke clears away; the vessel is taken, thanks to our preparations, and with a prize crew on board sent back to Newport. Or if fates are against us we are captured and carried away to wait and watch in the islands of the West Indies for a chance to return home. But our imagination has carried us too far and we must return to our story.*
>
> *Rhode Island in the early days, and for nearly a hundred years, was synonymous with Newport, which like Venice, depended on her ships for a place in the sun. She ploughed the sea. The back country was neglected, save as it furnished surplus products for her ships. Situated on an island, her only highway was the sea. Boats were a necessity, and her youth grew up to their management.*
>
> *Providence and Warwick, surrounded by forests travelled only by Indian paths, slow even for horses, found the water the easiest pathway from place to place. Narragansett Bay united rather than divided them, the load that could be packed on a horse was limited and but a fraction of what a boat could carry. Even the early General Assemblies of the colony at Newport were dependent for the presence of the mainland members upon the state of the wind and waves. The town of Providence when it instructed those*

who were to represent it at the meeting in 1647, at Newport, added, "We committee you unto protection of the Allmightie, wishing you a Comfortable voyage, a happy success and a safe return unto us againe, Yor Thankfull friends and neighbors Roger Williams Moderator."

The *Rhode Island Colonial Records* report:

It has been suggested that our early cemeteries were placed for convenience of access on our river points.

In the first code, that of 1647, prepared for commerce, "It is ordered that the Sea Lawes of Oleron, shall be in force amongst us for the benefit of seamen (upon ye Island), and the Chief Officers in the Towne shall have power to summon the Court and determine the cause or causes presented.

EIGHTEENTH-CENTURY COMMERCE

At the dawning of the eighteenth century, the colony included nine towns and 7,181 inhabitants. The first sixty years of this century were marked by increasing commerce, by privateering and by the colonies' participation in several of England's intercolonial wars.

In 1740–41, Governor Ward reported to the Board of Trade:

As the first settlers were not of the wealthiest sort, nor overstocked with servants, the greatest part of their money was unavoidably swallowed up in procuring provisions, clothing and utensils for husbandry and labor, to subdue and cultivate the soil; when it came to pass, that although there be several commodious harbors within this colony, and a part of the Atlantic ocean makes our southern boundary yet little or no navigation was carried on until about the middle of the present century; necessity engaging the inhabitants to employ the whole of their time and care—some to bring to, and manure the land, others to follow such trades and occupations as they were most capable of, for the support of themselves and those who depend on them. Indeed they had a small matter of money but that was chiefly the remains of what they and their fathers had brought into the country.

Navigation is one main pillar on which this government supports at present. We have now above one hundred and twenty sail of vessels

belonging to the inhabitants of this colony, all constantly employed in trade; some on the coast of Africa, others, in the neighboring colonies, many in the West Indies, and a few in Europe. Besides the two hundred soldiers raised for His Majesty's immediate service, the merchants of the town of Newport have equipped five privateers, with crews amounting in the whole, to near four hundred men, who are now cruising against the Spaniards.

A report in the state archives gives a list of vessels entering the port of Newport from June 5, 1744, to May 7, 1745, 52 foreign vessels and 114 coasters. All reports of the time indicate that Rhode Island's sea commerce was steadily increasing.

Shipbuilding was an early industry. A vessel was built at Newport for New Haven merchants in 1646, and the town of Providence granted half an acre on Weybosset Neck to encourage a shipwright to carry on his trade.

The commerce was largely the shipment of provisions to the West Indies in small Newport-owned vessels—sloops, schooners and scows operated by four to nine men and from forty to sixty tons burthen.

In addition to the horses required to turn the rollers of the West Indies colonies' sugar mills, Narragansett pacers were eagerly sought because of their easy gait for the use of the owners' wives and daughters. Lumber for construction purposes, cut in the forests of Maine and New Hampshire and along the upper reaches of the Connecticut River, was brought to Newport and shipped to Barbados and Jamaica.

On the return trips, our vessels brought back the staple island products molasses and cotton and many English goods received in exchange for the island cargoes sent to Europe.

These were the "sugar islands" with which we traded. A good market with a high price for sugar built fortunes that enabled their owners to enter the English Parliament and create a strong sugar interest at home and abroad.

As Massachusetts enshrined in its statehouse the "Sacred Cod" as the source and emblem of its successful commerce, so Rhode Island could set up a hogshead of molasses held aloft by a pair of Negroes. Molasses and its potent product—New England rum—were the lifeblood of Rhode Island commerce. Newport's golden age was nourished by molasses and rum and sprinkled with the tears of slaves.

Smuggling and Illicit Trading

Smuggling—otherwise known as illicit trading—was for many years a Rhode Island business, a recognized means of American livelihood.

The manufactured products of the northern American colonies, for the most part, were those of England, and therefore it was necessary to find a market elsewhere. The African trade, of course, demanded rum, but this product distilled from molasses was not an indigenous New England product. The market of the northern colonies was therefore the far-flung line of West Indian islands and Dutch Guiana. Consequently, because of the efforts of the British West Indian sugar planters, the Molasses Act was passed in 1733. A cry went up from New England that it was undone. This act laid a duty of six pence a gallon on molasses, nine pence a gallon on rum and five shilling per hundredweight on sugar imported from foreign colonies. From the beginning, the northern colonies had warned the mother country that it was only by the specie derived from the entire West India trade that they were enabled to buy manufactured goods from England. This view was presented by Rhode Island to the Board of Trade in 1764, when the tax on molasses was rigidly enforced.

In order to enforce and collect the tax, one customhouse was established on Rhode Island's four hundred miles of coastline—this seems not to be the supreme effort the Crown had in mind to collect the duty.

The people were united to avoid payment of duties, and customs officials preferred to turn a blind eye rather than incite the wrath of their seafaring merchant neighbors. The whole system in Rhode Island and Connecticut was loose. Shipmasters arriving in Rhode Island refused to take the usual oath, paid a penalty of £100 in paper currency (worth one-fifth the duty) and were admitted entry.

The North American traders sold their cargo in British West Indies for cash and then sailed to the French West Indies to purchase molasses.

One particular Rhode Island smuggling case received widespread publicity. This was the sloop *Enterprise*, in 1749, owned by Rhode Island deputy governor Jonathan Nichols and commanded by Richard Mumford. It was loaded at Leogram, Santa Domingo, with molasses and sugar bound for Rhode Island. The HMS *Cornwall* captured it.

Its papers and the testimony of its captain show a very interesting state of affairs, witnessing a regular system for the shipment of French molasses and

sugar despite all trade laws and with the collusion of the French officials and Rhode Island customs officials.

A very clever deception was instrumental in avoiding duty collection by British customs. Routinely, Rhode Island captains put ashore their sailors at Monte Cristo and then, with a Spanish captain, crew and passport, proceeded to the adjoining port of Cape Francois to exchange their cargo for molasses and sugar. Then they returned to Monte Cristo, where the Spaniards went ashore and the original crew returned on board, and sailed away to Rhode Island.

One more interesting story was the 1757 case of the sloop *Speedwell*. Captain Thomas Cornell, with a cargo of fifty-one boxes of spermaceti candles, six thousand bricks, eleven thousand shingles, one thousand staves, 1,100 hoops, onions, cutlery, cheese, eight hundred pounds of bread and five pounds of beef, put ashore, and with a Spanish pilot and four Spanish sailors, the vessel proceeded to Monte Cristo, where the cargo was sold. The vessel then proceeded to Port Dauphin and loaded sugar, rum and indigo. Upon its return to Monte Cristo, a New York privateer seized it. The supercargo (foreman), a Frenchman who lived in Newport for five years, had long been employed in this trade and now, by consent of the Newport owners, was to live at Monte Cristo and accumulate a ten percent commission from the country cargoes of molasses and sugar for shipment.

For thirty years, Rhode Islanders ignored the Molasses Act. However, in 1760 there was a serious attempt by the British government to enforce this law, and another in 1764, leveraging duties to interfere with the trade of the West Indies. This and other taxes ushered in sympathy for revolution. The officers enlisted to enforce the customhouse rule were without the expected loyalty to the edict. Rhode Island's seacoast is so extensive and has so many spacious harbors that the small number of customhouse officers complained they were not able to do much to prevent the illicit trade.

THE TRIANGLE TRADE

On June 6, 1763, the *Newport Gazette* reported:

> *On Thursday last arrived from the coast of Africa, the brig* Royal Charlotte *with a parcel of extremely fine, healthy, well limb'd Gold*

Aquidneck Island and the Founding of the Ocean State

Coast slaves, men, women, boys and girls. Gentlemen in town and country have now an opportunity to furnish themselves with such as will suit them. They are to be seen on the vessel at Taylor's wharf. Apply to Thomas Teckle Tayoor, Samuel & William Vernon.

The principal business in Newport, Bristol and Providence during the eighteenth century was the slave trade.

In 1708, the English Board of Trade wrote to the governors of the English colonies for information regarding the slave trade. This query was an endeavor to collect data for use of the Royal African Company:

It being absolutely necessary that a trade so beneficial to the kingdom should be carried on to the greatest advantage. The well supplying of the plantations and colonies with a sufficient number of Negros at reasonable prices is in our opinion the chief point to be considered.

Governor Cranston,[15] in his reply, gives a brief history of the slave trade and its status in Rhode Island. He wrote:

The Seaflower, *Captain Thomas Winsor, brought in 1696 forty-seven Negroes from Africa to Newport where fourteen were sold at £30 to £35 per head and the balance carried to the owners of the venture in Boston. In 1700, three Newport vessels sailed direct to the coast of Africa and brought their Negros to Barbados. There has been no African trade but this. Our only supply of Negros is from Barbados, averaging twenty or thirty a year at a price from £20 to £30. The yearly demand here for Negros is from twenty to thirty but the offspring of those they have already is sufficient to meet the demand. The general dislike our planters have for them because of their turbulent and unruly tempers causes our people to prefer white servants.*

In 1713, Cranston wrote an addendum:

Some merchants of the colony introduced rum to the coast of Africa and superseded the French brandy favored by the Africans. This colony annually sends about eighteen vessels carrying about 1,800 hogsheads of rum with a small quantity of provisions which have been sold for slaves, gold dust, elephants' teeth and cam-wood. These slaves are sold in the West Indies, Carolina, and Virginia.

> *From this deduction of our trade, which is founded in exact truth, it appears that the whole trading stock of this colony, in its beginning, Progress & End is uniformly directed to the payment of the debt contracted by the importation of British goods. Moreover, it clearly appears that without this trade it would have been, & always will be, utterly impossible for the Inhabitants of this colony to subsist themselves, or to pay for any considerable quantity of British goods.*

The colony of Rhode Island was living on molasses. The slave trade was for many years in the middle of the eighteenth century the great trade of Rhode Island. There must have existed thousands of documents in Rhode Island relating to the trade, especially in Newport, but they are now nearly all destroyed. Rhode Island, you will remember, was a pronounced antislavery state. There is reason to believe that descendants of those who trafficked in the trade were so ashamed of the nefarious doings of their ancestors that they destroyed all papers relating to their participation in the traffic.

The commercial activities of the colony centered on the triangular, or three-legged, voyages from Newport to Africa and then to the West Indies and back to Newport. A schooner would sail from Newport with hogsheads of rum and possibly some flour or other durable provisions, dry goods and on occasion iron bars and large copper pans and make its laborious way to the coast of Africa. Then, after a tedious voyage of forty or fifty days, touching at Cape Mount, it drifted along the Ivory Coast to the Gold Coast and on to Anomabu.

Here, if fortune were propitious, the captain would be happy to find numerous slaves herded up waiting for traders and New England rum correspondingly scarce, making a good market. If fortune frowned, the Newport captain would find the slave storage stockades depleted of merchantable Negroes and the harbors filled with rum-bearing ships, making a bad market. The state of the slave market influenced the length of the time spent on the coast. If the market was good, a captain quickly obtained his cargo and hurried away to dispose of it because it was perishable merchandise.

Prices varied. In 1756, William Vernon and William Redwood, well known and respected Newport merchants, took a note for 353 gallons of rum payable in good male and female slaves—men at 115 gallons each and women at 95 gallons each.

A great market for slaves existed in the West Indies, where the sugar plantations needed a constant supply of Negroes to counter the high mortality rates caused by the climate.

Aquidneck Island and the Founding of the Ocean State

A well-loaded slaver was an easy and valuable prize for pirates. It was easier to secure a cargo of slaves by firing a few guns at a poorly armed and undermanned trader than to barter and toil, exchanging rum for Negroes on the fever-haunted shores of the Gold Coast. Therefore, during the intercolonial wars, French privateers lay in wait off the African coast to prey on homeward-bound slavers fat with Negroes. Such was the unfortunate experience of Joseph Wanton,[16] the master of the sloop *King of Prussia*, who sailed a voyage of misadventure.

Wanton, a devout Quaker, followed the requirements of his religion, but he nevertheless engaged in the slave trade. He laid aside the peaceable principles of the Society of Friends to arm his sloop with three cannons, five swivel guns, five muskets and ten cutlasses—hardly the equipment expected for a peaceful voyage. Wanton sailed from Newport on April 1, 1758, for the coast of Africa with a crew of eleven men and one boy and a cargo of 124 hogsheads of rum and twenty barrels of flour. He arrived safely at Cape Mount on the windward coast of Africa on May 20. He immediately ran down to the great slave market and began his trading. Lying at anchor with his business only partially transacted, having on board fifty-four slaves and twenty ounces of gold dust, with sixty-six hogsheads of rum still in his ship's hold, he was pounced on by a French privateer with sixty guns and over five hundred men. Clearly, the odds were not in Wanton's favor. The privateer took the *King of Prussia* and its cargo after putting its captain and crew ashore. Wanton, with his mate and one seaman, obtained passage on the *Snow Fox*, arriving in Newport on October 13, 1758. What became of the other seamen and the boy is unknown. However, occasionally white men were captured as slaves, taken inland and sold to Arabs.

CARGO MANIFEST

The following ship's manifest was printed in the *Newport Historical Society Bulletin*:

Shipped by the Grace of God, in good order and well conditioned, by Jacob Rodriguez Riviera and Aaron Lopez in and upon the good Brigantine called the Ann *where of is Master, under God, for the present voyage William English and now riding at anchor in the harbour of Newport, and by God's Grace bound for the coast of Africa.*

98 Hogsheads & 14 Tierces New England Rum
8¼ casks of Lisbon wine
3½ barrels Madeira wine
19 kegs of cordial
2 Tierces Loaf Sugar
2 Barrels Brown Sugar
1 Barrel Vinegar
30 Sheep
39 Turkeys
28 Geese
21 Ducks and provender

Being marked and numbered as in the margin, and are to be delivered in like order and well conditioned at the aforesaid Coast of Africa (the danger of seas only excepted). In Witness whereof the Master of the said Brigantine has affirmed under 3 bills of lading of this Tenor and date and so God send the good Brigantine to her desired port in safety, Amen.
Dated at Newport, November 27, 1772, William English

At this late date, the day of slaves captured by ships' captains had long since passed, as had trading with native kings. The trading was now with English "factors," or intermediaries, for slaves already in stockades along the coast. What made a good market for the trading captain on the coast was a scarcity of rum and a surplus of slaves. Often, several ships congregated on the coast, and consequently the trading was poor.

In a letter dated October 27, 1736, Captain John Cahoone complained to his ship owner about poor trading opportunity:

I bles God I Injoy my health very well as yett: but am like to have a long and troublesome Voyage of it, for there never was so much Rum on the Coast at one time before, Nor the like of the French shippen—never seen before for no the hole Coast is full of them. For my part I can give no guess when I shall away, for I purchast but 27 Slaves since I have bin heaar, for slaves is Very Scarce. We have had Nineteen sail of us at one time in the Rhoad: so that these ships that are to Cary prime Slaves off is now forced to take any that Comes. Heair is 7 sail of us Rume men that we are Ready to Devul one another: for our Case is Desperit.

The record (1773–74) of the sloop *Adventure*, captained by Robert Champlain and owned by Christopher and George Champlain of Newport,

Aquidneck Island and the Founding of the Ocean State

in the *Trade Book of the Sloop Adventure* is in the Shepley Library, Providence, with notes by Professor Verner W. Crane (1927).

The captain and the owners' brother Robert kept the accounts. The outfitting of the sloop began early in 1773 and continued until it sailed on October 25. Besides the usual provisions of beef, pork, sugar, molasses, wine, beans, tobacco, bread and flour, the ship also carried 14,495 gallons of New England rum. The entire cost of the cargo and stores was £37,628. The crew numbered the master, two mates, a cooper, a cook, a boy and five seamen. In about five weeks, they reached Sierra Leone.

On the windward coast, they purchased rice and then sailed on to the Slave Coast. The trading business of the *Adventure* reached from Sierra Leone to Whydah in Dahomey, a distance of 1,250 miles.

Trading for slaves was done mainly at Cape Coast Castle and Anomabu. Here they stayed for about four months, and sixty-four slaves were obtained in exchange for rum, but the exchange rate was high. The equivalent value in money for women varied in price from £200 to £205 and for men from £220 to £225.

The slaves were sometimes bought from the regional chieftain but mostly from the European castles or stockades along the coast.

The account book lists day-to-day transactions, recording the outlay of rum and the income of slaves and provisions for their subsistence: wood, hogs, small pigs, fowl, shellfish, plantains and water.

After a successful trading period, with a full cargo, the *Adventure* proceeded to Grenada in the West Indies—a seven-week voyage. Only one slave death is listed in the ledger; this is considered a very remarkable fact. Either the slaves were in exceptionally good physical condition or exceptionally well cared for during the seven-week passage.

Usually, the opposite of "well cared for" slaves in transit was the norm. Tales are extensive about the smell of a slave ship being in the air long before the ship could be seen on the horizon.

These slaves were sold in the West Indies, and the proceeds were probably invested one-third in hogsheads of molasses and two-thirds in bills of exchange in London. In July 1774, after nine months at sea, the *Adventure* reached Newport. The gross profit of the voyage, as calculated by Professor Crane, was receipts (not including profit on the molasses) of £44,250 and expense of £62,750, leaving a net profit of £14,000, or 23 percent. Ultimately, despite the high price of slaves at Anomabu and Cape Coast Castle, it could be called a good voyage.

7
CONTINENTAL AND FEDERAL NAVY

PROLOGUE

From its infancy during the Revolution to its present-day sophistication, the United States Navy has continued an important presence in Newport and Narragansett Bay.

The first commander of the Continental navy, Rhode Islander Esek Hopkins, used the bay as a haven for his evolving fleet. After the Revolution, although the navy was small and often engaged in other conflicts on the world's oceans, American fighting ships were common sights in the bay.

During the Civil War, the navy came to Newport in a big way. To avoid capture by the Confederate offensive, the government moved the U.S. Naval Academy from Annapolis to Newport. The academy remained in Newport until the end of the war, when it returned to Annapolis.

In 1869, one of the most significant navy establishments was authorized by the secretary of the navy: the founding of the research and development of the torpedo station on Goat Island. The Naval Torpedo Station contributed greatly to the development of many forms of naval ordnance.

By 1913, the navy had acquired a boat landing in downtown Newport and built the Naval Hospital on the shore adjacent to Coasters Harbor Island. This expansion of naval facilities was a direct result of the nation entering World War I. As thousands of recruits came to Newport, the navy acquired Coddington Point, building barracks and training facilities

to accommodate the overflow from the training station on Coasters Harbor Island.

In 1940, the threat of war caused a rekindling of activity at the naval base. The base grew rapidly. Coddington Cove was acquired for a naval supply center, and a fuel storage and distribution center was built, along with a patrol torpedo boat training center and a net depot in Melville.

In 1955 and 1958, Piers 1 and 2 were built to accommodate ships of the cruiser-destroyer force and the service force. Naval supply and public works facilities expanded to support the fleet. Headquarters of the Commander Cruiser-Destroyer Force, Atlantic, were established in Newport in 1962; this command moved to Norfolk, Virginia in 1973.

Also in 1973, the active fleet moved from Newport, and a cutback of personnel and activities marked a general drawdown of facilities. Five previously independent commands were disestablished and their personnel absorbed into a new activity: the Naval Education and Training Center.

THE CONTINENTAL NAVY

On July 9, 1764, the British revenue schooner HMS *St. John*, commanded by Lieutenant Hill, captured an American brig said to have discharged cargo at Howland's Ferry in Tiverton without paying duties and attempted to carry off an alleged deserter from Newport. The townspeople, bent on revenge for these high-handed acts, proceeded to Goat Island, and in what was probably the first act of open resistance to British rule, they seized Fort George.[17] The fort's commanders turned their cannons on the British frigate HMS *Squirrel*, firing eight shots.

Newporters attacked another British ship in 1769, the armed sloop HMS *Liberty*. This time, however, they seized the ship and scuttled it at the end of Long Wharf off Goat Island's Gravelly Point. In 1772, Rhode Islanders, in the west bay just a few miles from the city of Providence, caught the British customs schooner the *Gaspee* and burned it to its waterline.

In 1773–74, British engineers conducted a thorough survey of Narragansett Bay and the islands "with a view to establishing a very extensive Naval Station, with dry docks, ship yards, hospitals, fortifications, &c." The approaching American rebellion ended all British plans for developing a naval base in Rhode Island waters.

Aquidneck Island and the Founding of the Ocean State

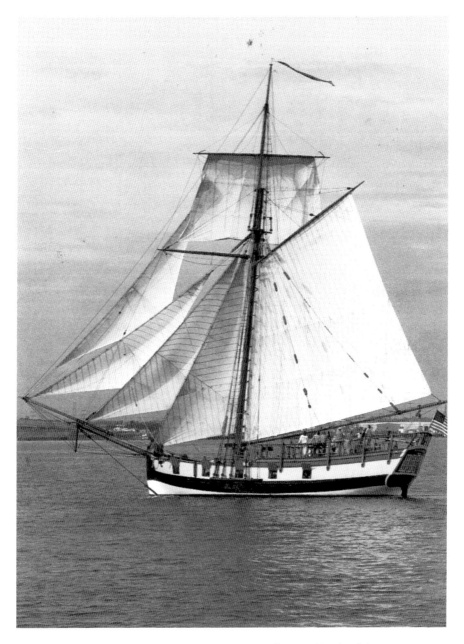

The twelve-gun Continental sloop *Katy* (1774) won the first naval battle of the Revolutionary War in Narragansett Bay. *Seaport '76 postcard.*

The actions of Rhode Islanders in general, and Newport in particular, angered the British. The Crown was determined to hammer the rebellious Rhode Islanders into obedience.

During the fifty years preceding the American Revolution, Newport had reached the zenith of its maritime prosperity. Newport was the fifth most prosperous commercial center in the original thirteen colonies. Only Philadelphia, Boston, New York and Charleston exceeded Newport in size and importance.

Newporters' original fear of vulnerability from the sea, which had led to the purchase and fortification of Goat Island more than one hundred years earlier, had come to fruition. The principal difference was that originally Newporters, chiefly of British stock, had feared attacks by pirates, the French or the Dutch. It was ironic that a British commander, Sir Henry Clinton, led the invasion when it finally did come.

Rhode Island next moved to create the Continental navy. The Continental Congress took the first steps by authorizing the fitting out of two vessels to interdict British trade. By December 1775, the so-called Rhode Island Plan, a comprehensive measure for construction of thirteen frigates, had been enacted.

According to *The Old Stone Bank History of Rhode Island*, volume IV:

> *In early 1776, came the actual birth of the American Navy, the result of the militant, unrelenting insistence of sea-minded Rhode Islanders. In fact, the proposal presented to the Continental Congress for an armed sea force was titled the "Rhode Island Plan," and no one has any reason to claim that the idea of an organized navy for the defense of the American colonies came from any other source than Rhode Island.*
>
> *Along the Narragansett Bay shorefront, everyone knew the sloop* Katy *owned by Mr. John Brown, wealthy and prominent ship-owner. Moreover, it was not many weeks after what happened in New England in 1775*[18] *that the Rhode Island Colony negotiated with Mr. Brown to take over the* Katy *and turn her into an armed vessel for the defense of this Colony. By vote and resolution of the General Assembly, the Committee of Public Safety was directed to appraise the sloop, come to an agreement with Mr. Brown for her hire, and immediately fit her out for naval service.*
>
> *The deal was consummated and no time was lost in overhauling and refitting the* Katy *and arming her with* [a battery of twelve guns] *four pounders and* [fourteen] *swivel guns, and procuring a sufficient number of small arms and all necessary stores and equipment, enough for a crew of eighty men exclusive of officers.*

Aquidneck Island and the Founding of the Ocean State

Abraham Whipple, heroic leader of the expedition that burned the hated ship [HMS] Gaspee *was appointed captain with the rank and power of commodore in command of the* Katy *and another smaller hired sloop,* [of eight guns] *named the* Washington. *Commodore Whipple could not boast of a very sizable fleet, but he was looking for action and so were his men.*[19]

On her very first cruise, down the Bay from Providence, somewhere off Conanicut Island the Katy *met a local packet that had been captured by the British and manned by a British crew. After a quick maneuver and bold approach, one of the* Katy's *four-pounders let loose; the packet turned tail and ran aground at the north end of Conanicut Island, deserted by her crew and promptly retaken by Whipple.*

On June 15, Whipple sailed with his command, down the bay and attacked two of the frigate *Rose*'s tenders, which he disabled, forcing one to retire under the guns of the frigate. He took the other as a prize. Because of the *Katy*'s light draught, he could keep out of the reach of the man-of-war.

In October, the Rhode Island General Assembly voted, with the consent of John Brown, that the colony should purchase the sloop with the boats, stores and accessories for $1,250.[20]

The Continental sloop *Providence* (1774–78). On March 3, 1776, U.S. Marines made their first landing from the *Providence* when they captured Nassau in the Bahamas. *Seaport '76 postcard.*

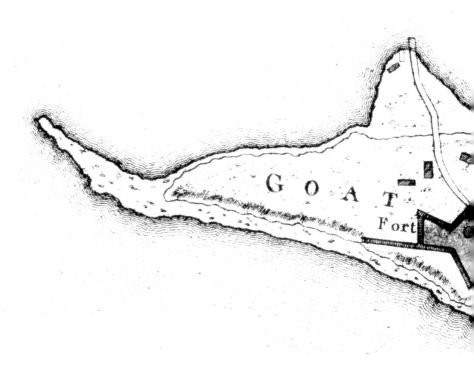

Diminutive Goat Island held a strategic defensive location in Newport Harbor. This 1777 sketch illustrates the protective plan of the Fort George profile and the few outbuildings extant.

Evidence is convincing that the first ship of the continental navy was the *Katy*. In the winter of 1775–76, Captain Whipple sailed the *Katy* to Philadelphia, where it was sold to the Continental Congress and rechristened the *Providence*. Its new commander was Captain John Hazard. Immediately thereafter, it joined the new Continental navy, the first American naval fleet, commanded by Providence native Esek Hopkins.

According to John Fitzhugh Millar in 1975:

> *The first operation of the Continental Navy was the capture of Nassau in the Bahamas on March 2–4, 1776. This operation gained Congress many heavy cannons taken from the forts at Nassau, some gunpowder, the Governor of Nassau as a prisoner, and suntans all around without the shedding of any blood. The inhabitants of Nassau tried to outdo each other in giving parties for the invaders. This was the first amphibious landing of the U.S. Marine Corps, and most of them splashed ashore from the sloop* Providence, *since she was small enough to get closest to the shore of all the ships of the fleet.*

Aquidneck Island and the Founding of the Ocean State

The Continental navy mounted a blockade and siege of Aquidneck Island in an effort to rout the English, which culminated in the large but inconclusive Battle of Rhode Island in 1778. This contest was the first effort of the Americans and their new French allies.

Unfortunately, the combination of a reinforced Newport garrison by a large British fleet, the shelling of the French fleet from Fort George and an ill-timed hurricane in April 1778 that severely damaged the French fleet, commanded by Comte Charles Hector D'Estaing, left the British still in control of Newport.

With a severe shortage of food and supplies, Sir Clinton left Aquidneck one year later. He decided that his troops would be more militarily useful in pacification of the southern colonies.

When the war ended, Aquidneck Island, and Newport in particular, faced devastation like nothing previously seen. The island's freshwater wells were polluted, the city's timber wharves were torn apart and burned as firewood and businessmen and trading houses deserted the town, moving their headquarters to Providence and Boston.

One would think that, in the attempts to recover from the ravages of war, all things naval would have had a bright future in Narragansett Bay and especially in Newport. This was not the case, however. Rhode Island played almost no part in building the American navy after the Revolution.

There was an attempt to establish a naval shipbuilding yard at Newport in 1798. The local politicians of the day were unable to persuade the Federalist Congress of the advantages of such an enterprise. However, the government did support building shipyards in Boston and Portsmouth, New Hampshire. Political pressure was no less a factor then than it is today.

Federal Navy and Goat Island

For the duration of the Revolution, the existing fortification was named Fort Liberty and, later, Fort Washington in honor of General George Washington. It was finally renamed Fort Wolcott to honor the services of Rhode Island's wartime governor, Oliver Wolcott.

In 1799, the town of Newport transferred ownership of Goat Island to the federal government for $1,500, with the express purpose of maintaining a military fort to defend Newport Harbor. The island came under the jurisdiction of the War Department, and during the following seventy years, defenses operated under the control of the U.S. Army.

Fort Wolcott was garrisoned until May 22, 1836, when the army was transferred to Florida to fight the Seminole Indians. This marked the end of Fort Wolcott's service as a garrisoned fortification; not a soldier remained on the island. The only inhabitant remaining was a civilian caretaker.

During the years after Goat Island and Fort Wolcott were abandoned, the area undoubtedly became a haunt for thrill-seeking boys and lovers in search of seclusion. Although considered a secondary fort to supplement Fort Adams[21] in times of war, it was never again used as an active fortification.

Peaceful quiet became the norm in Newport until the time of the Civil War. Fort Wolcott, along with Fort Adams, on the southwestern shore of

Opposite: Fort Walcott (1795–98) constructed under the direction of West Point engineer Major L'Enfant. This 1944 sketch of Fort George/Fort Walcott illustrates the changes made to the original fort plan. At this date, the Naval Torpedo Station is in full operation, and the old fort is being slowly swallowed by the new torpedo-manufacturing facility.

Aquidneck Island and the Founding of the Ocean State

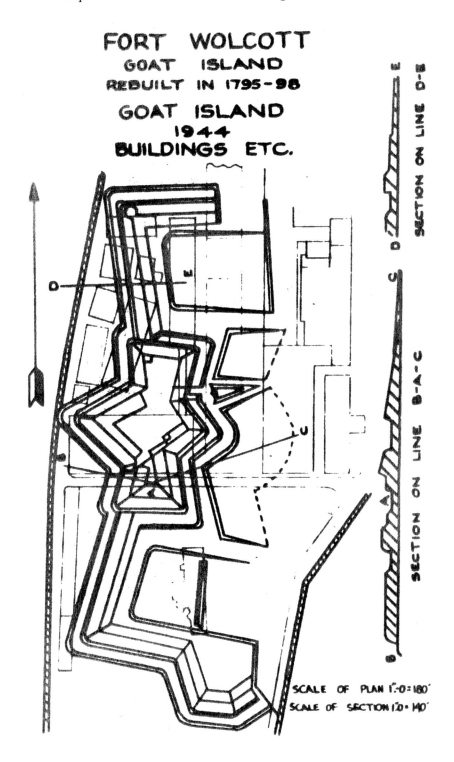

HISTORIC TALES OF COLONIAL RHODE ISLAND

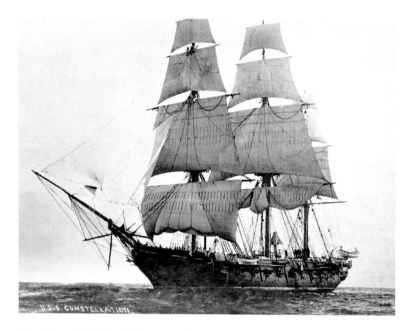

The frigate USS *Constellation* was authorized by Congress on March 27, 1794. It was launched on September 13, 1797. The *Constellation* took an active part in five wars. *Official USN photo.*

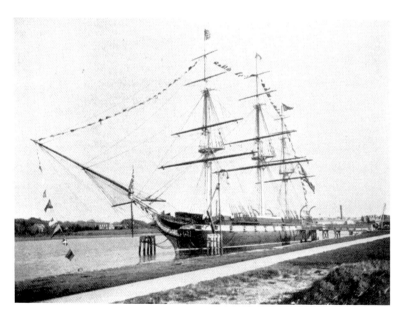

The USS *Constellation* berthed at the U.S. Naval Academy, where it was used as a training ship.

Newport Harbor, had fallen into disrepair in the intervening years. Tension and apprehension among coastal residents began to rise in the mid-1800s. It became increasingly apparent that discord between the states on the subjects of slavery and states' rights would impede a peaceful settlement.

On May 8, 1861, the calm of a balmy spring afternoon was shattered by the sound of heavy cannon fire. All of Newport rushed to the wharves and hills, concerned that the often-rumored Rebel attack on Fort Adams had begun.

Much to their surprise, they saw that it was the frigate *Constitution*, "Old Ironsides," its guns thundering an answer to the twenty-four-gun salute from Fort Adams. On board were 130 midshipmen from the recently evacuated Naval Academy in Annapolis. They were supposed to go to Fort Adams, but the staff took one look at the place and quickly began looking for suitable quarters in Newport, in a nicer part of town. Finding none to their satisfaction, they took residence at Fort Wolcott.

A few hours later, the steamer *Baltic* entered the harbor; on board were the professors, their families and every book and piece of equipment they could carry from the academy. The *Constitution* was soon joined by the Naval Academy school ships, the *Macedonian* and the *Santee*. These tall ships soon became a familiar part of the Newport skyline.

Naval Academy

In August 1861, the Naval Academy leased the Atlantic House Hotel, at the corner of Bellevue Avenue and Pelham Street, just across the street from Touro Park. There, and on Goat Island, the academy remained for the duration of the war. It was no accident that the navy chose Newport as the wartime location of the academy. George Bancroft, who as secretary of the navy founded the academy at its original location in Annapolis in 1845, was a life-long summer resident of Newport. To Secretary Bancroft, Newport seemed to be the perfect wartime location for the academy.

The War Department lent Goat Island to the navy and built temporary classrooms next to Fort Wolcott.

Although there were certain misgivings among the public at the beginning, the students' lives in Newport and the lives of native Newporters soon came around. It was not long before many of the upperclassmen and faculty found themselves involved in the Newport

A November 26, 1887 *Harper's Weekly* newspaper illustration of the solidly built Naval War College building on Coasters Harbor Island.

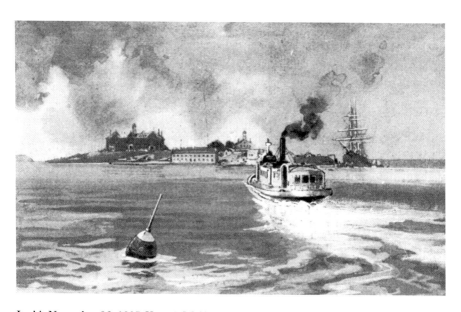

In this November 26, 1887 *Harper's Weekly* newspaper illustration, the viewer gets "a glimpse of the Training School and War College from Fort Greene."

social scene. Many of these midshipmen at Newport did make names for themselves as they continued in their naval careers.

Some of those early academy graduates were Benjamin Tilley, the first military governor of Guam and later a resident of Bristol, Rhode Island;

Charles V. Gridley, who at the Battle of Manila was given the famous order by Admiral George Dewey: "You may fire when ready, Gridley!"; and Rear Admiral Charles Sperry, class of 1862, who would later go on to be president of the Naval War College. Sperry established the first Boy Scout troop in Newport in 1911.

REAR ADMIRAL STEPHEN B. LUCE

Newport also gained some important advocates in the navy while the academy was here. Chief among these was Rear Admiral Stephen B. Luce, who had lobbied long and hard for a naval training facility in Newport. Luce was the leading intellectual in the service during that time, an individual of rare genius and ability in military and naval science.

Luce began his career in 1841 as a midshipman aboard the seventy-four-gun ship-of-the-line USS *North Carolina*, commanded by Newport native Matthew Calbraith Perry. Indirectly, therefore, his association with Narragansett Bay occurred at the very beginning of his career. Just how meaningful was the association is impossible to say. It was only twenty years later, at the beginning of the Civil War, that Luce demonstrated his interest in the region. At the time, he was assistant commandant of the fledging Naval Academy in Annapolis, Maryland. With events of the conflict so close to the academy, RADM Luce made the decision to move the academy elsewhere. It appears Luce was a strong proponent of Newport, the site chosen.

Before the conclusion of the war, Luce petitioned state and federal political figures on behalf of keeping the Naval Academy in Newport. Luce's efforts fell short, however, and at the end of the Civil War, political reality reared its head. The Naval Academy returned to its original site in Maryland.

Any fears that the navy would abandon Newport altogether were quickly dispelled, however. Soon after the war, a series of events was set in motion that has led to more than a century of continuous navy presence in the Newport community.

Luce directed his efforts at keeping the academy in Newport to Senator James W. Grimes, chairman of the Senate Naval Committee, and Assistant Secretary Gustavus Fox, complaining that Annapolis was not an ideal place for the academy.

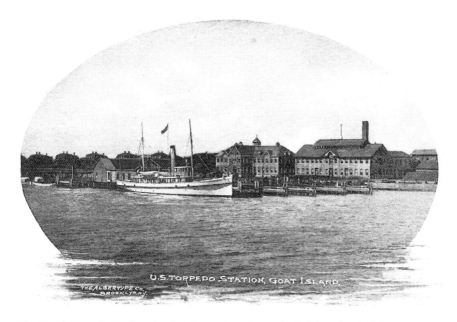

The Naval Torpedo Station showing the engineering and administration buildings, the tugboat *Lyden* and the torpedo boat piers. Postcard, circa 1915.

Chances for the Naval Academy staying in Newport were quite good. Maryland had exhibited strong Confederate sympathies during the war and was out of favor with the strong Republican Congress. However, total support was not forthcoming, resulting in the return of the academy to Annapolis. Luce later claimed that the return to Annapolis was the result of a political deal between Senators Grimes and Reverdy Johnson of Maryland.

There is some reason to believe that Luce may have been responsible for establishing the torpedo station on Goat Island. He made the decision for the site two months after President Grant took office.

After a visit to the torpedo station, Grace Herreshoff wrote the following in her 1902 monograph about Goat Island's appearance:

> *The aspect which the station presents, as one approaches it on a summer's day, is not without its beauty; with the winter days it is best not to concern one's self, for then the bleak winds, sweeping up and down the bay, seem to render even one's foothold insecure. In the summer, the ground is grass-covered; the vines embellish the six severely plain cottages in a row along the south part of the island, which are occupied by the officers constituting the personnel of the station. Even*

Aquidneck Island and the Founding of the Ocean State

The navy contracted the Herreshoff Manufacturing Co. of Bristol to build this combination ferry and firefighting boat called the *Wave*. In this December 14, 1907 photo, the *Wave* is testing its pumps and water gun.

a few tenderly cared for trees flourish before the commandant's quarters directly opposite the landing-pier, though elsewhere the neatly marked path and roads gleam white in the sunlight. Moreover, let it here be noted that the extreme neatness prevalent at the Torpedo Station is such as to remind one forcibly of the "holystoned" and orderly appearance of a great battle-ship [sic]. Over the front of the machine shop a number of ponderous torpedoes and tubes of obsolete make, with other objects of that nature, are regularly disposed on the lawn, and clumsy old submarine mines (one "ancient" example is dated 1880, such is the haste of modern invention!) mark the corners of the paths.

COMMANDER IN CHIEFS' VISITS

By the end of the nineteenth century, Newport's reputation as a summer playground for the very wealthy was well established. Presidential visits to Newport were greatly anticipated events by the public. The chief executives' visits usually included an inspection of the torpedo station.

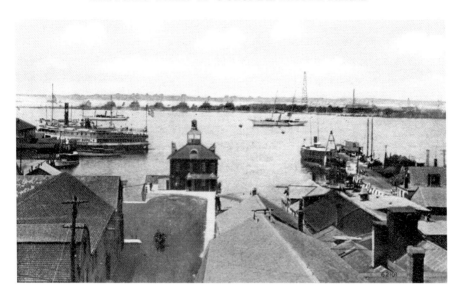

A bird's-eye view of Newport Harbor, the New York Yacht Club Station, the sound steamer the *Mount Hope* and the Naval Torpedo Station. Postcard, 1904.

Archibald C. Sherman noted:

> *On July 5, 1889, President Benjamin Harrison arrived in Newport Harbor aboard the U.S. Navy steam cutter the* Dispatch. *He received a tour of the Station and advised in aspects of the latest in torpedo technology.*
>
> *President Theodore Roosevelt was a frequent Newport visitor. As a former Secretary of the Navy and while President he was a constant advocate of a strong navy. During his many visits, his itinerary always included inspections of the War College and the Torpedo Station.*
>
> *A great change took place on Thames Street in 1903 when the [Federal] Government purchased the property of the Swinburne Peckham Co. for a Government Landing. This included not only the wharf and waterfront, but also the old moss-covered building on Thames Street.*

Three Decades of Expansion

By 1871, the Naval Torpedo Station had developed its version of Whitehead's weapon, the seventeen-foot-long "Fish," and was experimenting with a host

Aquidneck Island and the Founding of the Ocean State

of alternatives. Meanwhile, inventors in both Europe and America were competing to build a practical submersible torpedo boat, and by the mid- to late 1880s, there were about fifteen operational submarines built. From the beginning, the successful marriage of the submarine and the torpedo was clear, and indeed, when the U.S. Navy took delivery of the USS *Holland* in 1900, it came equipped with five eighteen-inch Whitehead torpedoes.

In 1906, Admiral N.E. Mason, chief of the Bureau of Ordnance (BuOrd), petitioned Congress for a torpedo appropriation of $500,000. Mason earmarked $150,000 of the appropriation to establish a U.S. Navy torpedo factory at the Naval Torpedo Station on Goat Island. When granted, the navy sent Lieutenant Commander Gleaves and Lieutenant Commander Davidson to the Vickers-Armstrong torpedo factory in England to study its manufacturing process of Whitehead torpedoes.

At the end of the Gleaves and Davidson study, the torpedo station began constructing a new torpedo-manufacturing building in July 1907. Estimated annual factory production was one hundred torpedoes and spare parts, and to support this effort, a major reorganization was required. Chief Clerk J.P. Sullivan became director of administrative reorganization, and Quartermaster John Moore set up the machinery and artisan workforce.

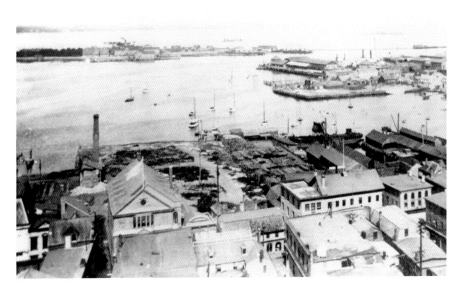

This circa 1915 westward aerial view presents a prospective of Thames Street buildings, the Municipal Pier, Long Wharf (mid-right), Newport Harbor and Goat Island in the upper background. *Official USN photo.*

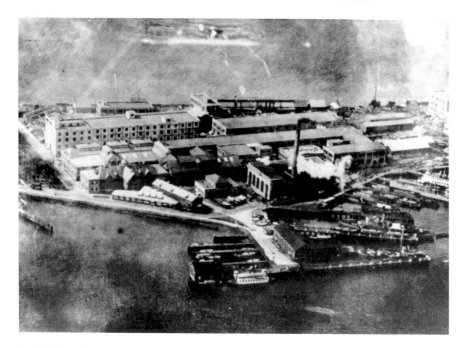

In this December 8, 1920 photo, Goat Island has become a major military industrial complex. *Official USN photo.*

In January 1908, before the factory was completed, the torpedo station received its first order to manufacture twenty eighteen-inch MK 5 Whitehead torpedoes, incorporating the new hot gas design powered by four-cylinder radial engines. These weapons were the first multi-speed (twenty-seven, thirty-six and forty knots) vehicles issued to the fleet. The forty-knot vehicles had a four-thousand-yard range.

In the summer of 1908, the new factory was completed and installation and checkout of production equipment initiated. Soon, additional space became necessary to provide needed manufacturing support facilities, including a foundry, pattern shop and forge. The torpedo station instituted an extensive expansion program to move the power plant close to the electrical laboratory and level the remnants of old Fort Walcott to free an area on the west side of the island for industrial growth.

By 1910, the torpedo station employed 445 civilian workers. The torpedo factory was in full production, and orders for more than one hundred Whitehead torpedoes were on the books. By September 1912, the initial twenty MK 5 torpedoes had been delivered from the U.S. Navy's first operational in-house torpedo factory. During these early years, approximately

Aquidneck Island and the Founding of the Ocean State

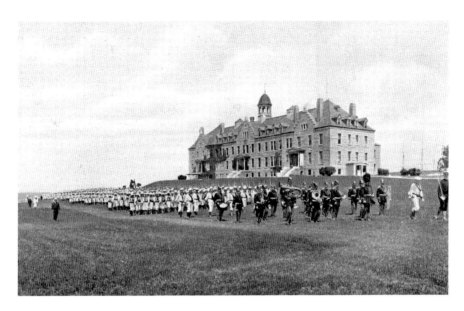

A full battalion of midshipmen marching in front of the War College building is seen on this circa 1910 postcard.

Pictured on this postcard, dated 1912, midshipmen from the War College are parading along Thames Street.

five hundred MK 5 Whitehead torpedoes rolled off the production line. Immediately upon completion of the original factory, a second factory was under consideration at the Goat Island site.

Getting the new torpedo factory built and operational was the priority task during the first decade of the twentieth century. The torpedo station was also involved in conducting basic research, developing new weapon concepts and providing technical support to the fleet. Training continued with both officers and enlisted men instructed in a wide range of formal classes, including torpedoes, diving, guns and gun control systems, mines, printing, torpedo boat and submarine operations, countermining and other subjects.

Post–World War II

The years following World War II brought sweeping organizational and program changes to the Naval Torpedo Station. With a new name and mission, the migration of all navy facilities from Goat Island was completed, and the island returned to civilian ownership. After only a short move of two miles north on Narragansett Bay to Coddington Cove, the station settled on several acres of farmland, where it remains today. From the production-oriented role imposed by the war to meet the demands of rapidly expanding technology, the torpedo station, through changes in mission, broadened and synthesized its program responsibilities. The generic beginnings of much of the work currently at the Naval Undersea Warfare Center are direct results of extraordinarily successful programs developed during this period by the center's predecessors—the Naval Underwater Ordnance Station (NUOS) and the Naval Underwater Weapons Systems Engineering Center (NAVUWSEC), formally the Central Torpedo Office.

During the earlier navy laboratory reorganization in the 1970s, the Naval Underwater Sound Laboratory, New London, Connecticut, had joined Naval Underwater Weapons Research and Engineering Station (NUWRES) to become the Naval Underwater Systems Center (NUSC), with broad responsibilities across the entire spectrum of undersea warfare. Finally, in 1992, the systems center teamed with the Naval Underwater Weapons Engineering Station, Keyport, Washington, to form today's Naval Undersea Warfare Center (NUWC), with headquarters in Newport. Today, the center

Aquidneck Island and the Founding of the Ocean State

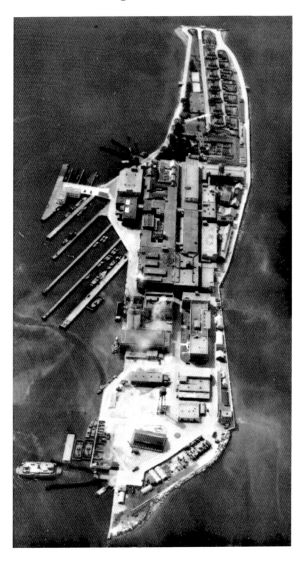

As seen in this 1945 aerial view of the Naval Torpedo Station facilities on Goat Island with torpedo boat piers facing Newport Harbor, the compound now envelopes nearly the entire island. The old harbor defense fort no longer exists. *Official USN photo.*

is active in research, development and in-service engineering for torpedoes and other tactical submarine-launched weapons: Antisubmarine Warfare (ASW) mobile targets, countermeasures, unmanned underwater vehicles (UUVs), sonar, underwater fire control and a wide range of submarine auxiliary components, such as periscopes and antennas.

Today, Goat Island, offshore of fashionable downtown Newport, is the site of a modern luxury hotel, high-end condominiums and a marina. Only a fragment remains to excite memories of the once-bustling industrial complex.

8
HISTORIC LANDMARKS

This chapter is concerned with some of the most intriguing structures of man and nature existing in Newport and its environs.

The first and no doubt the most fascinating structure in New England is the so-called Viking Tower in Newport's Touro Park. The scholarly thesis that follows will be controversial in some quarters; however, it is a thoughtful alternative to the persistent legend of Newport's Viking Tower.

This monograph is the work of Mr. Scott Wolter. The mention of color refers to colored points of interest in photographs and drawings not available for this publication.

VENUS ALIGNMENTS IN THE NEWPORT TOWER OF RHODE ISLAND

A monograph by Scott F. Wolter

From *Epigraphic Society Occasional Papers* 26, no. 1 (2010)
An earlier version of this article appeared in *Ancient American* 12, no. 77
(February 2008)

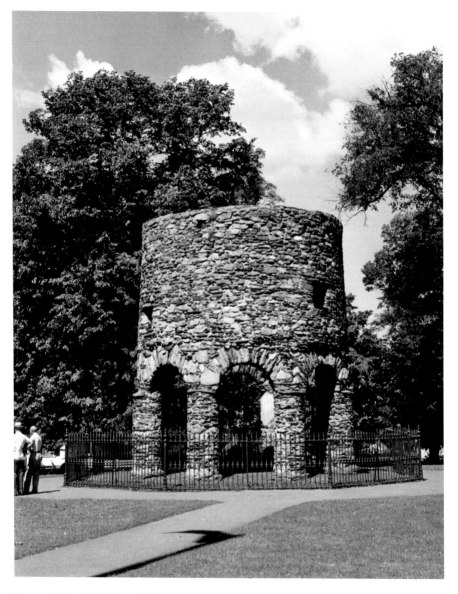

Newport's iconic Old Stone Mill, also known as the Viking Tower. *Newport Chamber of Commerce.*

After months of speculating about the possibility of astronomical alignment features with the planet Venus having been originally built into the Newport Tower, on December 12, 2007, I decided to investigate it. The question first came up after roughly three years of research into the history of the ideology

of the medieval Orders of the Cistercian monks and the military brethren they created in 1128, commonly known as the Knights Templar. The planet Venus became the focus upon learning that the origin of the matriarchal "Goddess"-based religions that began with many ancient cultures' reverence of the brightest star in the sky as a female deity.

Recent research by British historian Alan Butler and me suggests the medieval Cistercians/Templars also revered the "sacred feminine" by using the Virgin Mary as a metaphor for the Goddess. These Orders appear to have understood the sacred historical connection with Venus and used astronomical cycles of the planet in conjunction with geometry and mathematics in a variety of both practical and religious ways.

The capturing of astronomical alignments of the sun, moon and Venus in standing stone sites and churches allowed the builders to use these structures as clocks and calendars and for determining longitude (using solar and lunar eclipses) and latitude. The religious aspect of alignments was primarily associated with the winter and summer solstices and spring and fall equinox. Much of the solar and lunar alignments in the Newport Tower have been documented by professor emeritus Dr. William Penhallow. His research effectively proved the numerous windows and niches inside the tower were intentionally made to capture various astronomical alignments. Professor Penhallow was apparently unaware of Venus alignments and did not study them.

This paper proposes that Venus alignments are captured in the Newport Tower, which provides evidence consistent with medieval Cistercian/Templar construction practices that reflect in large part, their religious ideology. On December 19, 2007, I traveled to Newport, Rhode Island, to investigate this theory with fellow researcher and friend David Brody.

We selected three mornings (December 20, 21 and 22) that bracket the winter solstice. After making arrangements to gain access to the tower with the City of Newport parks officials, Susan Cooper and Scott Wheeler, who were most accommodating, we arrived each morning at 4:00 a.m., just as Venus was rising in the southeast sky. To our great frustration and disappointment, never once were we able to actually see the planet due to heavy cloud cover. However, we were able to make some important observations. The first observation was that there is a horizontally oriented rectangular opening in window W-6 that would allow the light from Venus to enter the tower and hit niche N-4 as predicted. However, we did *not* observe an opening in window W-7 that would allow light from Venus to hit niche N-1 or N-2 (likely N-2). One possibility is that past renovations to the top of the tower may have inadvertently altered the configuration of the window.

Future research into Venus alignments by qualified researchers may provide validation to their existence:

> *Two distinct windows, roughly 10 inches square, ere constructed within a foot of the top of the Newport Tower. Window W-6 is located over column P-4 on the southeast side (left), and window W-7 is located over window W-3 and column P-7 on the west side (right).*

Morning Star Venus Alignment

The first alignment involves the four-year period in the eight-year cycle when Venus is a morning star in the southeastern sky. Its altitude is approximately twenty-two degrees, which is the same angle of a line drawn from the square niche (N-4) on west inside wall up through the small square window (W-6) near the top of the tower on the southeast side.

On the west inner wall of the tower, niche N-4 sits directly above the egg-shaped keystone (Orphic egg of Freemasonry?) in the archway between columns P-7 and P-8.

On December 20, 2007, David Brody and I investigated possible Venus alignments in the Newport tower. After climbing a ladder to niche N-4, we found a small rectangular opening in window W-6 confirming that an alignment with Venus was possible. Further research is necessary to confirm the alignment's existence.

Evening Star Venus Alignment

The second alignment involves the four-year period in the eight-year cycle when Venus is an evening star in the west-northwestern sky. Its altitude is again approximately twenty-two degrees, which is the same angle of a line drawn from the square niche (N-2) on the east, southeast inside wall up through the small square window (W-7) near the top of the tower on the west side.

On the southeast inner wall of the tower niche N-2 sits above the archway between columns P-4 and P-5.

When we checked the W-7 to N-2 alignment, there was *not* a visible opening to allow Venus to be seen. It is unclear why this is so. However, it is possible that an opening did exist at one time, but the opening has been altered due to repairs of the upper walls. Former Rhode Island governor

Aquidneck Island and the Founding of the Ocean State

William C. Gibbs reportedly told a historian named Benson John Lossing, who was visiting Newport in 1848:

> *Roughly between 1775 and 1780, the British [occupying Newport] used the tower for an ammunition magazine. When they had to evacuate Newport, they tried to destroy the old building by igniting a keg of powder in it. The masonry did not collapse, however, and the only result was the loss of the roof and two or three feet of the upper stonework of the wall.*

It is unclear if two to three feet above the present height of the tower was lost altogether, or if the present top two to three feet was first lost and then repaired.

> *The yellow arrow marks the line from the inner wall niche N-4 to window W-6, which points toward the planet Venus when it is a morning star in the southeastern sky. The red arrow marks the line from the inner wall niche N-2 to window W-7, which points toward Venus in the west-northwestern sky. The angle of both lines from horizontal is about twenty-two degrees.*
>
> *This diagram shows a bird's-eye view of the path the light of Venus travels through the window (W-6) in the upper southeast wall to the niche (N-4) on the inside of the west wall. As an evening star, the light of Venus travels through the window (W-7) in the upper west wall to the niche (N-2) on the inside of the southwest wall.*
>
> *On December 22, 2007, the rays of the rising sun on the Winter Equinox cast a vertical rectangle that hits directly on the egg-shaped keystone in the west archway between columns P-7 and P-8.*

In spite of the heavy overcast weather and our failure to see the planet Venus, the other important objective of our trip was successfully accomplished on the morning of December 22. At 8:15 a.m., we arrived at the tower to record the precession of the rectangular box of sunlight through window W-2. Researcher Jim Egan was the first person known to have photographed this event in 2001. He presented the information at the first-ever Newport Tower Symposium on October 27, 2007. However, he did not offer an interpretation as to what the illumination might represent. The light of the rising sun on the winter solstice shines through the southern window (W-2) and casts a rectangular-shaped box of sunlight that first passed through the west-facing window (W-3) at approximately 7:45 a.m. As the sun continued rising at an increasingly higher angle through window

W-2, the rectangular box of light widened and moved downward and in a north and easterly direction from W-3 along the west-northwest wall inside the tower. At approximately 9:00 a.m., the box of sunlight hit squarely on and brightly illuminated the light tan–colored egg-shaped keystone in the west-northwest archway.

When personally witnessed, it is obvious this illumination of the egg-shaped keystone was intentionally incorporated into the structure by the original builders. The following is my interpretation of the explanation for this feature that is consistent with the religious beliefs of the medieval Cistercians/Knights Templar.

The round tower was considered a church nave that represented the womb of the sacred feminine (Goddess). The egg-shaped keystone on the inside was constructed as the Orphic egg inside the womb. When the light of the sun, considered a male deity, strikes the egg on the winter solstice, it was allegorically inseminated. The allegorically fertilized embryo inside the womb underwent gestation until it hatched with the "birth" of the new ideology (Goddess worship), along with new life (spring), in the New Jerusalem.

> *Beginning at 8:15 a.m. on December 22, 2007, a rectangular-shaped box of sunlight passing through window W-2 moved progressively with the rising sun, downward and north along the west-northwest inner wall of the tower. At roughly 9:00 a.m., I was able to photograph the rising sun's rays illuminating the egg-shaped keystone on the west-northwest archway of the Newport Tower.*

References

Butler, Alan. *The Virgin and the Pentacle: The Freemasonic Plot to Destroy the Church.* United Kingdom: O Books, 2005.

———. *The Goddess, the Grail, and the Lodge.* United Kingdom: O Books, 2006.

Means, Phillip Ainsworth. *Newport Tower.* New York: Henry Holt and Company, 1942.

Penhallow, William. "Astronomical Alignments in the Newport Tower." In *The Newport Tower: Arnold to Zeno.* Edgecomb, MA: NEARA Publications, 2006.

The following descriptions of historic landmarks are included in the publication Picturesque America, *circa 1880–90.*

The Old Stone Mill

In the following strains, Mr. Longfellow tells how "the Viking old" found his way from "the wild Baltic's strand" to our strange shores and built here "the lofty tower" by the sea, commonly known as "the old stone mill":

> *Three weeks we westward bore,*
> *And, when the storm was o'er*
> *Cloud-like we saw the shore*
> *Stretching to leeward;*
> *There for my lady's bower*
> *Built I the lofty tower,*
> *Which, to this very hour,*
> *Stands looking seaward.*

We wish that we could believe in our having so respectable a piece of antiquity in Rhode Island. Inasmuch as this interesting and unique structure dates back to the prehistoric times of the colony, no record of its construction in existence, and, still further, as it has a close resemblance to certain edifices still existing in Northern Europe, many have been willing to accept the tradition that it must be of Danish origin. One theory is that this old ruin was originally an appendage to a temple and used for religious offices, as a baptistery. Others suppose that it was erected as a tower of defense and that, after the walls had crumbled until they were reduced to their present height, a wooden mill was erected on the summit.

The first authentic notice of the edifice is found in the will of a Mr. Benedict Arnold, dated 1677, in which he bequeaths his "stone-built windmill" to his heirs. About the middle of the last century [eighteenth] it was surmounted by a circular roof; and one of the old inhabitants, in the deposition signed in 1734, says, "It is even remembered that when the change of wind required that the wings, with the top, should be turned round, it took a yoke of oxen to do it." There is abundant tradition to show that it has been used for various purposes, and a hundred and fifty years ago, it was known as the Powder-mill—the boys, as late as 1764, sometimes finding powder in the crevices; and, at a later period, it was used as a hay-mow. It is somewhat singular that such a substantial and peculiar structure should have been erected simply as a windmill, but this may be explained by the facts that the first wooden mill was blown down in a great storm that occurred in 1675; the Governor

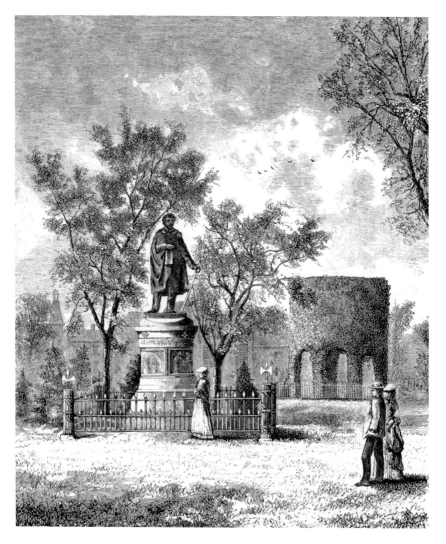

Commodore Perry's statue and the Old Stone Mill in Touro Park. Steel engraving, circa 1880.

Arnold was unpopular with the Indians and would be likely to build a mill that would withstand both storm and fire, and *look* like a fort at least; and, still further, he may have seen old mills in England of the same style—there being an engraving in the *Penny Magazine* of 1836, of one near Leanington, which is the very counterpart of the Newport mill. The various traditions connected with this old relic impart to it a special interest; and, unless it is upheaved by the earthquake or demolished by lightning, it is likely to stand for many generations.

Aquidneck Island and the Founding of the Ocean State

COMMODORE PERRY'S STATUE

At a little distance from the Old Stone Mill, on the easterly side of the public square, stands the statue of Commodore Matthew Calbraith Perry, erected by his son-in-law, Mr. Belmont. The material is bronze, and the accurate proportions, the graceful attitude, the well-disposed drapery and the speaking likeness, combine to give this statue a high place among our works of art. It would be well if other wealthy citizens of our republic should follow Mr. Belmont's example.

HARBOR FORTIFICATIONS

In entering Newport Harbor, Fort Adams, forming an angle on the right-hand corner, presents to the eye a singularly beautiful and picturesque appearance. Fortress Monroe [on Goat Island] is the only structure of the kind in the United States that exceeds it in size and cost, and a few years ago it would have seemed as if its massive walls must be strong enough to resist any assault that could be made upon them, and its multitude of ponderous cannon have been too formidable to allow the passage of any ship that floated into the waters of Narragansett Bay. But guns have recently been constructed that would send this granite pile, with its bastions and battlements, flying into the air like broken crockery; so that its use, as a citadel of defense, is at an end. At the same time the necessity of such a protection against the attacks of a hostile fleet has ceased; just under the guns of the fort lies what is known as Torpedo Island [Goat Island], where scientific men are now making and testing a new submarine projectile, which no precaution can hinder from finding its way to the keel of the ship that ventures near the shore, and blowing it to fragments. The morning and evening gun may continue to salute the break and the close of the day for many years to come, the Stars and Stripes to float over the fortress, the soldiers to keep watch and ward upon the walls, but it will no more be regarded as a stronghold of defense—only as an interesting relic of the past.

Fort Adams is a favorite place of resort with the summer residents of Newport, especially on the afternoons when the regimental band plays and the dashing down of the carriages and the clatter of hoofs over the step, stone

declivity under the frowning archway which opens into the spacious parade-ground, covering a space of eleven acres, and the roll of vehicles around the broad circular drive that surrounds the enclosure, make a pleasing change from the somewhat dull and monotonous military routine to which the officers and soldiers are subjected. The amount of money that has been expended here by the government—more than a million and a half of dollars—make it a very costly place of amusement, and might have been spent more profitably; but amusement is better than carnage, and if these modern improvements in the science of war should put an end to all strife, none will mourn.

Entering the harbor on the left your eye rests upon a small, oval fort, gray time warn, and dilapidated standing on the island of Conanicut [Jamestown], and known by the somewhat inexpressive name of "Dumplings." A controversy is now pending in regard to the date of its erection, some persons contending that it was built long before the Revolution, while others believe that it was thrown up by the British at the period when their troops occupied Rhode Island Colony. The first historical notice of its existence is found in a letter addressed by General Pigot, commander of the English forces, to Sir Henry Clinton, in which he says, "The guns of Beaver Tail and Dumpling are unserviceable, as the French fleet entering the harbor would cut off communication with Conanicut." The date of this letter is 1778. The fort has been left for many years to the corroding wear and tear of the elements, but, while the interior works have been gradually destroyed, the outer walls remain as complete and firm as they ever were. As a means of defense it would be of little service in these days, however thoroughly it might be manned, for one of our modern shells dropped into the center would blow the whole affair to fragments. Compared with Fort Adams, one of the largest and most completely equipped defenses on our shores, which, with its massive walls and long rows of gun, frowns upon Dumpling from the opposite side of the bay, this little tower looks somewhat insignificant; but, as a picturesque ruin, it has its charms, and has become a favorite place of resort for pleasure-partied, who cook their fish and bake their clams on the spot that once resounded to the thunder of artillery. For a century the winds have beat upon the old fort, the cross of St. George has waved over it; the French fleet swept round it as the vessels moved up to their winter anchorage in the harbor; the Stripes and the Stars long ago supplanted the British ensign; it is more venerable than the Republic; and we trust that it will be left undisturbed for ages, as it is one of the few memorials in existence of our early history, and may do something to take away the reproach brought against us by our brethren over the sea that we have no ruins in the United States.[22]

Aquidneck Island and the Founding of the Ocean State

Brenton's Cove

Brenton's Cove is approached by a causeway leading to Fort Adams and affords one of the finest views that can be obtained of Newport: "The tall and delicate spires of the churches cut sharp against the blue sky; the public buildings stand out in noble relief; and the line of houses, as they rise one above another on the hill side, is broken by open grounds and clusters of shade trees. Each spot on which the eye may chance to rest recalls some event that happened there in earlier times." Looking out from this cove, you might once have seen poor Burgoyne sailing for England after his sad defeat; Cook's famous ship the *Endeavor* was condemned, dismantled, and left to

Brenton's Cove.
Steel engraving,
circa 1880.

decay upon these shore; the *Macedonian*, prize of the frigate *United States*, was brought to anchor here; the British fleet, under Lord Howe, and the French fleet, under D'Estaing, both sailed by this rocky cove, one bringing misery and the other joy to the hearts of the inhabitants of old Rhode Island.

Taking the road leading west, we pass the remains of the house built by Governor William Brenton, through grounds that were in his day "adorned with rare and costly plants, gravel-walks, groves and bowers, and all that wealth and a refined taste could furnish," until we come upon the southern shore, where Brenton's Reef stretches for a mile or more into the sea.

In the picture all is placid and serene; but, when the breakers dash upon that fatal reef, and the strong waves whiten its jagged ridge, is a place of terror. Many a vessel has been wrecked there; and the moldering gravestones along the edge of the ocean show where the bodies of the drowned sailors were once buried. Why they should have been deposited there, where the winds and the waves sound a perpetual dirge, and the spray of the ocean always dampens the sods, which cover them, instead of being taken to some rural ground, where the birds sing, and flowers bloom, we do not know. No doubt, the hands of strangers buried them, and perhaps, after all, this was the most fitting place for their bodies to rest; and these humble memorial stones to the gay crowds who drive by, as the summer sun is sinking in the horizon, have suggested many a solemn thought.

Spouting Rock

Following the southern shore, we next come to what is known as the Spouting Rock. After a southeasterly storm, the apparatus is in working order; and, during the "season," multitudes assemble there to see the intermittent fountain play. The construction of the opening beneath is such that, when it is nearly filled and a heavy wave comes rolling in, the pent-up waters can find relief only by discharging themselves through a sort of funnel into the air. It is, however, a somewhat treacherous operator; for a long time there may be no spouting done; and, even when the waves roll in from the right quarter, it is not easy to tell just when the horn intends to blow. If the interested couple depicted in our sketch remain standing much longer where they are, before they know it the fountain may spout up some forty or fifty feet, and they will go home with drenched clothes and a wet skin. However, the ocean view

Aquidneck Island and the Founding of the Ocean State

The Spouting Cave. Steel engraving, circa 1880.

is, at this spot, so indescribably grand after a storm, that the temptation to linger as near the edge of the rocks as possible is almost irresistible, and we have seen many a gay company pay a watery penalty.

Purgatory

Beyond the bathing beach, where hundreds of fashionable people may be seen dashing about in the waves on every pleasant day, rise the precipitous rocks, with the deep and sharp-lined fissure, known as "The Purgatory." How it ever came to be called by this singular name, tradition does not inform us. A little beyond this chasm, there is a pleasant spot, shaded by trees, and commanding a beautiful view, which is known as "Paradise"—so that, when a stranger in that region asks the way, he is likely to be told that he must pass by Purgatory to Paradise.

The opening in the cliff extends one hundred and sixty feet, and is fifty feet deep at the outer edge. It is from eight to fourteen feet wide at the top, and from two to twenty at the bottom. It was once supposed that the water at the base was unfathomable; but at low tide, it is actually not more than ten feet in depth.

It was formerly the prevailing theory that the fissure was occasioned by a sudden up-heaving of the rock; but, after careful examination, Professor Silliman came to the opinion that it was probably formed by the gradual eating away of the softer portions of the stone at a very early period.

Like most places of the kind, Purgatory has its legends.

Some little time after the settlement of the country by the whites, an Indian woman murdered one of the colonists, to revenge wrongs inflicted

Purgatory, sometimes referred to as "Lover's Leap." Postcard, circa 1905.

upon her people. Walking, one day, near Purgatory, she was accosted by a person, appearing to be a well-dressed Englishman, who proposed to fight with her. The stout woman was not unwilling to accept the challenge, and in the struggle she was gradually dragged toward the edge of the chasm, when her opponent seized her in his arms, and leaped into the abyss. At this moment the cloven foot appeared, his goodly garments fell off, and he was revealed in his true satanic personality. Why the devil should have felt himself called upon to interfere in this way to punish the woman for the wrong that she had done to the English settlers is not known; but as the print of his feet and marks of blood are still visible on the stones, it is not for us to gainsay the story. At any rate, it is easy to see that such a belief on the part of the Indians might have tended to promote general security.

Another legend pertaining to this spot is not quite so tragic, and perhaps can be better authenticated. A beautiful but giddy girl, heir to a large estate, had for some time received special attention from a young man, in all respects her equal, and whose affection, not withstanding appearances to the contrary, she warmly reciprocated in her heart. But the passion for coquetry was so strong with her, that she could never resist the temptation to torment her admirer; and, one day, as they stood together on the brink of Purgatory, and he was pleading with impassioned eloquence, for some pledge or token of love from her, she said, "I will be your wife if you will show the earnestness of your devotion to me and your readiness to obey all my wishes, by leaping across this abyss." Without a moment's hesitation, the young man sprang to the other side of the rock, and then, politely lifting his hat, he complimented the beautiful girl upon her charms, told her candidly what he thought of her character, bade her final adieu, and she saw his face no more. After this, as the tale runs, she went mourning all her days.

Berkeley's Seat

[The Very Reverend George][23] Berkeley's Seat is in Paradise, within easy walking distance of the house which he built and occupied nearly a century and a half ago [circa 1730]. Out of regard to the memory of Charles I, to whom he was indebted for certain favors, he called his place Whitehall, one

Berkeley's Seat. Steel engraving, circa 1880.

Aquidneck Island and the Founding of the Ocean State

On this O.E. Dubois photo postcard is Bishop Berkeley's Middletown home, which he named Whitehall out of respect for his benefactor, King Charles I.

of the palaces occupied by the king. It is still standing and in good repair. There is the room, which he occupied as a study with its tiled fire-jambs, and low ceiling, and undulating floor, and the little chamber where he slept; and it is pleasant to think that, in the sunny courtyard adjoining, he once walked—perhaps discussing with his friends the state policy of Walpole, or the probable future of the new Western land, "whither the course of empire" had already begun "to take its way," or the medical virtues of tar-water, or it may be some of the profounder problems of the soul which occupied his thoughts. When the weather was favorable, he betook himself to the sheltered opening in Paradise rocks, which is now consecrated by his name. This he is said to have fitted up with chairs and a table. Tradition says that it was in this rocky cave he wrote his "Minute Philosopher." With the broad expanse of ocean before him, and its monotonous roll sounding in his ear, it may be that he was able to give his thoughts a wider range, and fix them more intently upon the subtle questions which he was so fond of contemplating, than was possible in the pent up little room where he kept his books. It may have been easier for him to bring his mind to the conclusion that there is nothing in the universe by *soul* and *force*—no organic substance, no gross matter, nothing

but phenomena and relations and impressions—than it would be if he were shut in by doors and walls, and nearer to his kitchen.

This was the Newport[24] of Berkeley, chosen by him, as a residence because of its superior fertility as well as natural beauty, for the good dean was something of a farmer as well as a metaphysician.

9
THE NEWPORT POORHOUSE

On the morning of Friday, June 25, 1819, many of Newport's most prominent citizens gathered and proceeded to the waterfront, where they embarked on boats that transported them across the slender span of water to the small, mostly deserted island called Coasters Harbor Island. The objective of the journey was to witness the laying of the cornerstone of the Newport Asylum, the town's poorhouse.

During the late eighteenth century and throughout the nineteenth century, social welfare advocates advanced the argument of reform in poorhouse construction as a means of social control of an emerging culture of benevolence. In the history of poorhouses in nineteenth-century Rhode Island, the paramount reason for poorhouse construction was the isolation and removal of paupers from the view of the wider refined population.

Throughout the decades between 1820 and 1870, economy was the most frequently recurring theme of reformers and town officials who recommended poorhouse construction. Also, reformers thought it a priority to cut the costs of pauper relief and support of the poor; cutting taxes appeared to be the most important argument in favor of building poorhouses. The public often complained of being harassed on the street by beggars who should be working for their daily bread. Reformers sought to exercise control over unsavory street beggars.

In the long view of the poorhouse movement, it was not as successful as hoped in keeping costs down. The movement did affect the lives of the needy. Poorhouses increased the social isolation of paupers from day-to-day

Historic Tales of Colonial Rhode Island

The Newport Poorhouse on Coasters Harbor Island, circa 1832. *Naval War College.*

interaction with the general population, which in the minds of taxpaying property owners was a desirable outcome of the movement.

Early poorhouses were places of last resort for Rhode Island's poorest of the poor. Newport built one in 1723, and in 1756, Providence built one. In 1822, the Town of Bristol built a "House of Industry."[25] At the Bristol Poorhouse, inmates were encouraged to work the town-owned farm for their subsistence; all excess produce was sold, and money generated from the sales was used for the upkeep of the poorhouse. Some towns provided direct cash assistance. Other towns allowed residents of poorhouses to help with their support by begging on the streets before returning to the poorhouse at night.

After 1750, Newport town councilors required paupers to wear badges on their clothing, obviously marking them as dependents of the town. Both the authorized begging and the badges were an attempt to reduce taxpayers' expenses on behalf of the needy, thus ensuring that only those willing to accept the social shame of dependence on the generosity of the greater part of society would actually ask for town money.

Newport's privileged saw the 1819 poorhouse as addressing two issues: taxes and benevolence.

In his 2007 *Rhode Island History* article, Grabriel J. Loiacono writes:

> *The poorhouse that was so celebrated by Newport's elite in 1819 was probably the second built in Rhode Island since the mid-eighteenth century.*

Aquidneck Island and the Founding of the Ocean State

In arguments that would resound in other towns for decades after, the proponents of the new poorhouse promised that it would relieve the tax burden of the town's care for its needy and would provide better, more humane care for the needy than was previously provided. The Newport "Asylum," as the poorhouse was called, would also prefigure one of the most significant effects of poorhouses on the lives of the poor: it would effectively isolate its inmates from the rest of the town. Indeed, the site of the Newport Asylum, on a small island which for years did not even have a bridge to the large island on which Newport itself is situated, was emblematic of the effects of the new poorhouses on the poor of Rhode Island.

Newport taxpayers' chief motivation for approving a new poorhouse was that it promised to reduce taxes levied to support the poor. As in most Rhode Island towns, Newport's town government included an overseer of the poor, whose job it was to warn our needy outsiders and to ensure that needy Newporters were provided for. With the approval of the town council, the overseer of the poor allocated food, firewood, clothing, and money to those Newport natives in need. At the end of the year the town treasurer assessed the taxpayers for the cost of this relief, along with other town expenses, proportioned according to the amount of real and personal property each taxpayer owned. The taxpayers paid a different amount each year, depending

The former Newport Poorhouse, now incorporated as part of the Naval War College, circa 1884. *Naval War College.*

HISTORIC TALES OF COLONIAL RHODE ISLAND

The sentry post at the entrance to the Naval War College, circa 1890. The old poorhouse building is in the upper left of this vintage photo.

on how much money the town had spent that year. In the early nineteenth century, spending on poor relief was often the single largest item in the budget, and it was often the cause of increases in the local town tax.

Tax increases were, to say the least, unpopular.

The old almshouse was located outside the larger populated town area. The location chosen for the new almshouse was removed to the seclusion of Coasters Harbor Island. The island, in the eighteenth century, was used as a pestilence quarantine station and was the site of a smallpox hospital. During the British occupation of Newport, sick British and Hessian solders and sailors were housed here. On old British maps, the island is identified as "Pest Island" and "Smallpox Island."

Obviously, Newport's elite were not eager to rub elbows with either poverty- or disease-stricken citizens as in the days prior to the poorhouse building frenzy. Those receiving public subsistence, before being housed in a public facility, as a class were far from respectable. Their habits of vulgar drunkenness, dissolute idleness and begging were offensive.

The solution for ridding the streets of Newport of these disagreeable denizens was their relocation on an island out of the sight of the town's respectable citizens.

10
Architectural Resources

Newport was at first an outpost of civilization that became a thriving commercial port and capital of a colony. Revolution and occupation by enemy and friendly forces reduced the old town to the condition of a sleepy seaside backwater, where its greatest charm is now found in the quaint old-time aspect of its homes and public buildings, which represent the best work of eighteenth-century builders.

The Baptist church established here in 1640, except for the one in Providence, is the oldest in the United States. Here also was built the first public school in America; open to all, it is possibly the first school supported with public funds. Newport was a cosmopolitan city with a principle of religious tolerance that attracted Quakers, Baptists, Moravians, Congregationalists and Sephardic Jews.

The center of downtown Newport is the Parade, now known as Washington Square. Located here is the statue of Oliver Hazard Perry, the hero of Lake Erie. It stands nearly opposite the old Seixas Mansion, Perry's last residence. At the head of the Parade is the old statehouse, built in 1739, which until about 1930 was used as the county courthouse. At the opposite end of the Parade is the Old Brick Market, designed and built by Peter Harrison in 1763. Close by, on the corner of Marlborough and Farewell Streets, is the old Nichols House, which in 1739 became a popular public house called the White Horse Tavern. Below is Long Wharf, where Washington and Rochambeau reviewed the French troops and where the funeral cortège of Admiral de Tierney landed in 1780.

Since 1947, the Preservation Society of Newport has been the guardian of the rich and varied legacy of Newport's fine buildings. From the architecture of Newport's pre-Revolutionary era to the age of the palatial summer cottages of the nineteenth century, the preservation society has preserved and promoted the best of the old town's heritage.

Several of the following histories of Newport buildings are excerpts from a 1933 pamphlet issued by the Newport Chamber of Commerce; those excerpted passages are identified with [NCC].

REDWOOD LIBRARY AND ATHENAEUM

An interesting piece of colonial Newport is the Redwood Library on Bellevue Avenue. Founded on September 4, 1747, as the successor of the

The National Historic Landmark the Redwood Library, designed by Peter Harrison in 1748, contains the oldest library room in continuous use in the country. Its collection of American paintings is outstanding. *Newport Chamber of Commerce.*

Philosophical Society of 1730, with which Bishop Berkeley was closely associated, is probably the seventh-oldest existing library in the country. Abraham Redwood and a group of his friends and associates established the Company of the Redwood Library in 1747. The Original Collection of 751 titles has grown to a collection numbering more than 160,000 volumes. Unlike the other libraries, the Redwood still uses its original building, built in 1750 and enlarged in 1859, 1875 and 1913. The architect of the original building, which is now the Belleview Avenue end of the structure, was Peter Harrison, one of the most famous colonial architects. The architectural style is of Classical design. It is in the style of a Roman Doric temple with portico and wings, the model probably derived from a 1735 edition of Andrea Palladio's architecture. Other specimens of his work in Newport include the Market House and the Touro Synagogue. [NCC]

The Quaker Meetinghouse

The first apostles of Quakerism arrived in Newport in 1657. Their creed was welcomed, and the leaders of the community adopted the faith. For over a half century, Rhode Island was led by Friends; for much of this time the governors were Quakers. During the next century, four members of the Wanton family, members of the Quaker faith, filled the governor's chair.

The annual meetings of Friends of New England were held in Newport, with records continuous from 1671.

The first meetinghouse of the Quakers built in America is on Marlborough Street. Because of its construction style, the oldest part of this fine structure, dating from 1699, is known as the "Old Ship Room." This most interesting carefully preserved seventeenth-century relic is a memorial to the Quakers, to the building's historic value and its architectural purity. [NCC]

Old Colony House

At the head of the Grand Parade, as it was called by the British, now called Washington Square, stands the stately Colony House. This fine, impressive

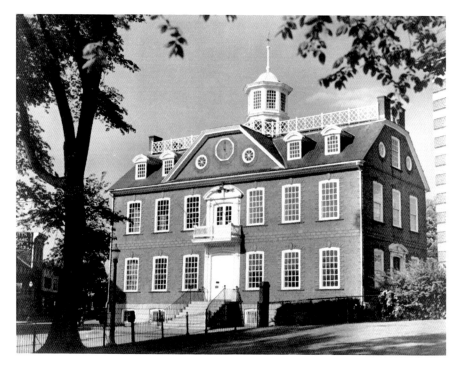

The 1739 Colony House is a rare example of a colonial-era government building. It is a National Historic Landmark. *Newport Chamber of Commerce.*

building of brick and stone foundation and trimmings, with ample doorways approached by a wide flight of steps, a balcony on the second story and that air of distinction which age and history have imparted to it.

Built in 1739, from plans of Richard Munday, it had the status of being the finest building in the colonies and today certainly holds its own with any American public building now extant.

Its interior shows throughout a wealth of beautiful and artistic detail. The history of the colony and afterward of the state of Rhode Island is most intimately associated with this stately building. In its early days, its uses varied for several purposes, as a courthouse, public meetings, religious and social functions of importance. The first lectures on medical science delivered in the country were those of Dr. William Hunter given in the Council Room in 1756.

From the balcony, in 1761, the death of King George II was proclaimed. The ascendancy of King George III was celebrated in the building by an elaborate banquet, the last times that such ceremonies were ever to take place in Rhode Island.

Aquidneck Island and the Founding of the Ocean State

Here in 1766, citizens assembled to celebrate the repeal of the Stamp Act. Three years later, the non-intercourse movement was endorsed by a meeting called for the purpose. In this building sat the commission to investigate the burning of the HMS *Gaspee*. Here the public assembled for first meeting in Rhode Island to resist the importation of tea from England. Here the General Assembly accepted the Declaration of Independence, and it was read from the steps to the assembled people.

During the Revolution, the British and French used the building as a hospital. The French chaplains used the South Chamber for the reservation of the Blessed Sacrament and the celebration of Mass.

When Washington visited Newport and his French allies, he was royally entertained at dinner in this building and, since that time, Adams, Jefferson, Jackson, Fillmore and other presidents have been officially received within the ancient walls.

In 1790, the convention that adopted the Constitution assembled here and made Rhode Island the thirteenth state in the United States. Newport was designated as one of the state's two capitals, and in this building, known until 1900 as the statehouse, the legislature had an annual session at which the election of governors and other state officials was proclaimed from its balcony. [NCC]

TOURO SYNAGOGUE

Jews immigrated to the Rhode Island Colony from Holland as early as 1658; they were benevolently welcomed and given sanctuary in the colony. About 1760, Rabbi Isaac Touro came to Newport from Jamaica after leaving Holland. Touro was a distinguished scholar and theologian with a strong devotion to the Hebrew faith. He soon became a leader among the Jewish people and an associate of men of culture and political stature. Prior to Touro's coming to Newport, there appears to have been a regular organized congregation but no temple dedicated to worship, and services were conducted where convenient and opportunity afforded. The original Jewish settlers founded the congregation Jeshuat Israel (Salvation of Israel) in 1658.

To provide a place of worship, Rabbi Touro, with the cooperation of his fellow religionists and their friends, purchased land on the former Griffin

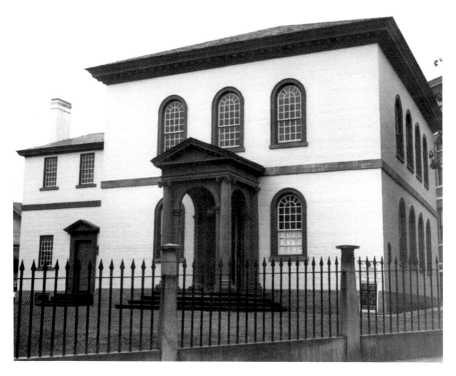

Touro Synagogue, built in 1763, is a National Historic Landmark. Touro is the design of Peter Harrison. It is considered one of the most beautiful houses of worship in America. *Newport Chamber of Commerce.*

Street. The edifice's foundation was laid on August 1, 1759, and dedicated on December 3, 1763. The architect, Peter Harrison, also designed Blenhein House in England and many historic Newport buildings.

After the British evacuation of Newport in 1789, the first session of the General Assembly conducted business in the edifice. The Superior Court of Rhode Island also met in the temple. [NCC]

HUNTER HOUSE

Hunter House is one of the finest examples of Georgian Colonial architecture from Newport's mid-eighteenth-century "golden age." Hunter House was built and decorated when the great mercantile families lived aristocratic lives, building harbor-front mansions overlooking their trading

Aquidneck Island and the Founding of the Ocean State

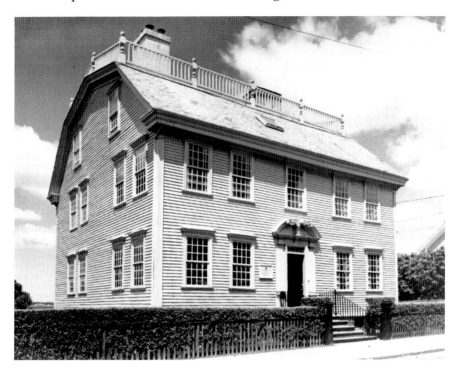

The Hunter House on Washington Street is the finest surviving house of pre-Revolutionary Newport. Built in 1748, it ranks among the ten best examples of Colonial residential architecture in America. *Newport Chamber of Commerce.*

ships and warehouses and entertaining in grand style. They bought furniture and silver from local artisans and were the patrons of such important early painters as Robert Feke and Gilbert Stuart.

Between 1748 and 1754, Jonathon Nichols Jr., a prosperous merchant and colonial deputy, constructed the north half of Hunter House. After Nichols's death in 1756, the property passed to Colonel Deputy Governor Joseph Wanton Jr., who was also a successful merchant. He enlarged the house by adding a south wing and a second chimney, transforming the building into a formal Georgian mansion with a large central hall.

During the American Revolution, Wanton fled from Newport due to his Loyalist sympathies. When French forces occupied Newport in 1780, the house became the headquarters of Admiral de Ternay, commander of the French fleet. After the war, William Hunter, a U.S. senator and President Andrew Jackson's charge d'affairs to Brazil, acquired Colonel Wanton's house. The Hunters sold the house in the mid-1860s, and it passed through a series of owners until the mid-1940s.

Concerned that the house would fall into unsympathetic hands, a group of citizens led by Mrs. George Henry Warren purchased the house in 1945, initiating a preservation effort and forming the Preservation Society of Newport County. The preservation society restored Hunter House to the era of Colonel Wanton (1757–79).

BRICK MARKET

This classic market building at the corner of Long Wharf and Thames Street dates to 1760. The General Assembly of the colony passed an act establishing a lottery to raise funds for the benefit of building a "Brick Market." The structure is the design of renowned architect Peter Harrison. Harrison's other credits include Touro Synagogue and Redwood Library in

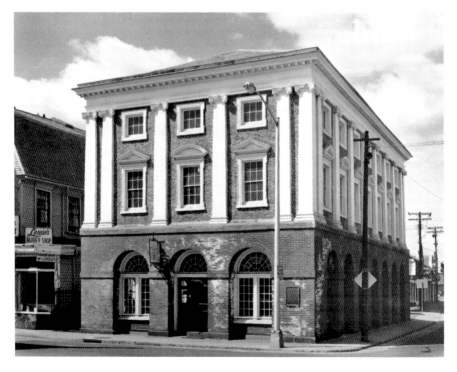

The Brick Market on Washington Square is a National Historic Landmark. The building is a 1762 design by Peter Harrison. In continual use since its construction, it is now restored to its colonial-era elegance. Photo circa 1950. *Newport Chamber of Commerce.*

Newport, Christ Church in Cambridge and King's Chapel in Boston. This building has always played an important role in the daily lives of Newporters.

It originally functioned as an open-air market and granary, with offices on the upper floors. The building's history has varied in use over the past 252-plus years, including a printing office, a theater and a town hall. It has been altered and renovated frequently over the centuries. In 1928–30, the building was completely restored under the guidance of Norman Isham, and it was again restored before 1993 under the auspices of the Brick Market Foundation, led by Ralph Carpenter.

Owned by the City of Newport, it is managed by the Newport Historical Society. The Brick Market building is now home to the Museum of Newport History and the Museum Shop.

White Horse Tavern

In 1652, Frances Brinley constructed the original building on the corner of Marlborough and Farewell Streets. In 1673, William Mayes bought the lot and enlarged the building to become a tavern. Other functions of the

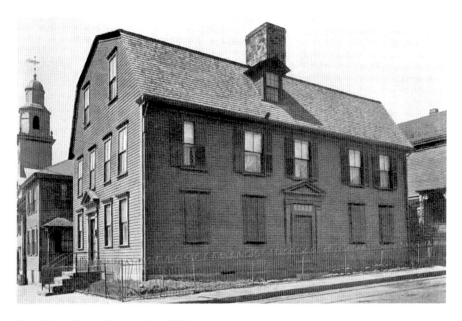

The White Horse Tavern, circa 1922.

building include use for large meetings, as a Rhode Island General Assembly meeting place, a courthouse and as a city hall. William Mayes Sr. obtained a tavern license in 1687, and William Mayes Jr., a well-known pirate, operated the tavern through the early eighteenth century. Owner Jonathan Nichols named the operation the White Horse Tavern in 1730. During the British occupation of Newport, troops were quartered here.

Tradition says that when the General Assembly met in the tavern, some considerable controversy ensued as to the direction that the statehouse, soon to be built, should face. Some legislators thought it should face the tavern and be in a direct walking line from it, but others urged that it should face the water, which opinion fortunately prevailed.

In 1952, after decades of neglect as a boardinghouse, Newport's Van Bueren family donated money to the Preservation Society of Newport to restore the building. After restoration, the building was sold and once again is operating as a private tavern and restaurant.

Tillinghast House

John Tillinghast built his house in 1760; it is a typical example of the well-to-do merchant-class residence of the eighteenth century. Located on upper Mill Street, it has a commanding view of Touro Park and the Old Stone Mill. The Tillinghast House has been enlarged several times, and the original doorway has been replaced by an entry porch known as a portico. Nevertheless, the grandeur and symmetry of this high-style Georgian mansion are still very much evident.

Tillinghast, a representative to the Rhode Island General Assembly in 1744 and 1749 and a wealthy merchant and ship owner, became heavily involved in privateering.

The house has been the home of Colonel Archibald Cary, commander of the Second Rhode Island Regiment in the Continental army; Pardon Tillinghast; and Governor William Gibbs.

During the winter of 1780–81, the house was occupied by the French regiment of engineers and was the headquarters of General Nathanael Greene. Here also were entertained Baron Steuben, Lafayette and Kosciusko.

Aquidneck Island and the Founding of the Ocean State

The following observations concerning colonial and early American architecture of Newport, Rhode Island, are taken from a narrative by Kenneth Clark that appeared in the June 1922 White Pine series of Architectural Monographs.

The early American Newport architecture found in the downtown historic district of the old town is a delight to the student of architecture and to the eye of the history enthusiast. Certainly, the history of this old seaport is traced through its rich inventory of eighteenth- and nineteenth-century residences and public buildings.

To most people, Newport is the summer playground of the rich and famous, majestic yachts and the palaces of wealthy Victorian-era barons of industry. It is also true that Newport is one of Rhode Island's "showplaces," popular with middle-class summer tourists who seek in the old town memories and associations of a former, simpler time.

The old historic district lies along the harbor, originally consisting of two streets, Thames Street and Spring Street, paralleling the shoreline and terminating in the Parade, known as Washington Square. In the narrow streets of the town along the waterfront there remain many structures of the Revolutionary and post-Revolutionary period.

Sadly, most of the buildings extant from the town's early prosperous century were neglected and many mutilated beyond restoration. Newport did not seem to regard these properties with the proper reverence deserved. With few exceptions, they were falling to ruin; many of them altered for commercial use, and others, fine mansions of a former day, became tenements housing day laborers. Happily, an enlightened cadre of architects and historians came to the rescue of these buildings; otherwise, they would surely not exist today.

Many fine houses, however, remain, and few sections of the state can boast of better individual examples. The general impression of architectural type that is gained in the course of a walk around the streets is one of smallness of scale and refinement of detail, essentially domestic in feeling and character. Many of the doorways are rich in a peculiarly naïve ornamental treatment, with Corinthian caps that never appeared in important architect's handbooks. However, they are nevertheless beautiful on their expression of the work of the master artisan of the day, who, perhaps deficient in knowledge of the pure classic detail, has evolved a somewhat primitive expression that exudes originality and is worth studying.

The architecture of our old coast towns, Newport included, built and lived in by seafarers, seems to bear the mark of a culture that is not easily accounted for, except as the expression of an innate refinement, broadened by contact with the Old World.

VERNON HOUSE

Perhaps the most conventional house in Newport, and one of the best preserved, is the Vernon House at the corner of Clark and Mary Streets. It is in excellent condition and remains as it was in pre-Revolution days. Metcalf Bowler built it in 1758,[26] and in 1773, it came into the possession of William Vernon, a wealthy merchant and ship owner. It remained in the Vernon family until 1872.

The Comte de Rochambeau occupied the Vernon House during his stay as commandant of the French forces in 1780. During his occupancy, many brilliant fetes and balls were hosted by the Comte in honor of distinguished

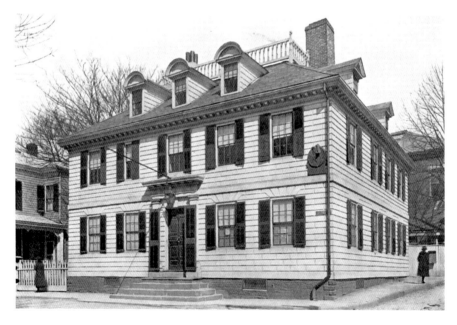

The spacious Vernon House was Comte de Rochambeau's headquarters during the French occupation of Newport, photo circa 1922.

Aquidneck Island and the Founding of the Ocean State

visitors and townsfolk. Here, General George Washington was welcomed on March 8, 1782, conferring with the Comte. Eyewitness accounts of Washington's visit say he wore the insignia of a maréchal of France and was received with all the pomp and display of a royal visitation (see Chapter 5).

There is a legend that the house is haunted by the spirit of a Frenchman. During Rochambeau's occupancy, the young Comte Axel de Fersen, an aide to Rochambeau, also lived in the house. The story is that the young Comte was a lover of Marie Antoinette, in whose name he fled France to protect because they could scarce look at each other without disclosing the love in their eyes. There is a sculpture of the queen in the old house, and the ghost of her lover is said to hover in the hall where her bust reposes.

WANTON-LYMAN-HAZARD HOUSE

The Wanton-Lyman-Hazard House, at the corner of Broadway and Stone Street, is one of Newport's earliest examples that remain in anything like their original condition. Local tradition dates this house "before 1700," and the primitive trimming in the interior of the attic story seems to substantiate

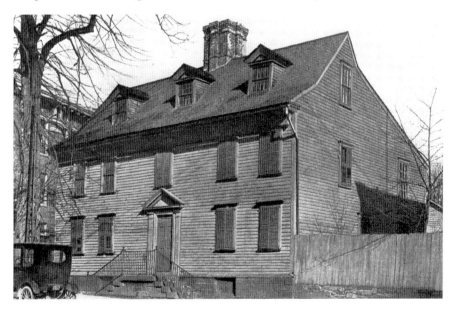

The Wanton-Lyman-Hazard House is seen in this circa 1922 photo.

this claim, as does the covered plaster cornice of the façade, a treatment that is most unusual and of which there are few remaining examples.

According to the Newport Historical Society:

> *In 1757, Martin Howard Jr., a lawyer and ardent Loyalist, bought the house. In 1765, Howard and other members of a Tory group known as the Newport Junto wrote a widely read pamphlet in which the opponents of the crown were criticized for their disregard of Royal and Parliamentary authority. As a result, during the Stamp Act riots in Newport later that year, Howard and two other Junto members were hanged in effigy on Washington Square and a crowd attacked and vandalized their houses. Howard fled Newport under the protection of the British.*

BULL MANSION

The old Bull Mansion, standing at the "First Mile Stone" on Broadway, is a fine foursquare manor house of the 1750 period. Its walls are rusticated,[27] and its beautifully proportioned roof with a rudiment monitor break in it

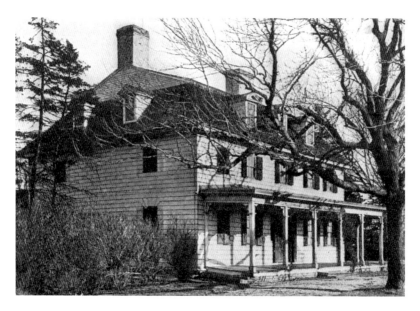

The 1750 Bull Mansion. Note the nineteenth-century addition of a farmer's porch, photo circa 1922.

has much character. The addition of a farmer's porch later has marred the general effect, but an idea is obtained from the end elevation of its appearance before the porch was added. The roof is odd in that it has both dormers and a monitor break in which there are no windows. Judging from its detail, the roof construction is of the same date as the main house. There are several houses in Newport with full monitor roofs of the typical Rhode Island type, as seen in Providence and Bristol.

JOHN BANNISTER HOUSE

The John Bannister House (now referred to as "The Prescott" because it was once the headquarters of British general Richard Prescott) is located at the corner of Pelham and Spring Streets. It was built between 1737 and 1767 as the residence of John Bannister and his family, who left town at the

A fine view of the unusual recessed entrance of the John Bannister House is the subject of this 1922 photo. The Bannister House was the headquarters of British general Richard Prescott before moving to Overing Farm in Portsmouth, where he was captured by Colonel William Barton.

beginning of the British occupation of Newport. The house has a gambrel roof of rather fine proportions, with three well-designed dormers. The recessed entrance motif is a feature rare in Newport, and its treatment here with colonnades and an elliptically arched head is well thought out. The moldings of the cornice supporting the soffit are beautifully profiled and form an interesting contrast to the stubby crown.

11
A Gallery of Palatial Cottages

Great Estates of the Gilded Age

In 1947, *Look* magazine noted:

> During Newport's mid-nineteenth century "Gilded Age" two- and three-million-dollar homes were called "cottages" by their free-spending owners. Single parties cost as much as $100,000. One grande dame was known to set aside $300,000 at the start of each Newport season for entertaining. A party given in Newport's palmy days was a lavish, bitter, six- or seven-week competition—marked by originality and oddity. Mrs. William Astor ruled supreme, her annual ball the high point of each season (because her ballroom would seat but 400, the magic number became the symbol of the elite). On one occasion Harry Lehr invited a hundred dogs and their masters to a "Dog's Dinner," serving stewed liver and rice, fricassee of bones and shredded dog biscuits. For sunshine and salt water, society went to the exclusive Bailey's Beach.

From the mid-1800s and through the decades of the 1900s, America's fabulously wealthy came to Newport for their socializing pleasure: horseback riding, polo and coaching, sailing, fishing, tennis, croquet and golf.

Newport's mild summer climate began attracting visitors from New York, Boston, Maryland and other hot, humid southern states. The trickle of

visitors became a flood soon after the first large hotels came on line in the mid-1820s. The focus of the summer vacation hotels ran for about thirty years, until about 1855.

By the 1860s, it was no longer chic to lodge at a hotel for the season; it became imperative for the truly elite to own or rent a cottage. While the number of cottages was increasing, the grand hotels were closing. During this period, Newport boasted 250 summer houses; about 100 were rentals, and the rest were generally owner-occupied.

The well-designed aristocratic cottage-building frenzy began in the 1830s and continued until the turn of the century. During these decades of little or no federal income tax, European immigrant artisans working for extremely low wages built the grand palaces. The first of the early cottages was a Gothic residence called Kingscote, built for Georgian planter George Noble Jones. Kingscote is built on a more "human" scale than the later marble palaces such as the Breakers, Elms and Rosecliff.

Most historians agree that the end of Newport's golden age of great stone mansion building is 1914. The days of the horse-drawn carriage gave way to the horseless carriage. Automobile transportation was fast becoming the most convenient way to travel, which made Southampton, Long Island, the new popular summer resort for the young breed of social elite.

Belcourt Castle

The building of the King Louis XII–style castle began in 1891 for thirty-three-year-old Oliver Hazard Perry Belmont. The sixty-room villa was the summer home of Belmont and the former Mrs. Alva Erskine Vanderbilt. They used this eccentric palace for only six to eight weeks of the year.

Belcourt Castle is the design of architect Richard Morris Hunt. Begun in 1891 and completed in 1894; construction cost $3.2 million in 1894, a figure of approximately $80 million in today's dollars. Belmont employed

Opposite, top: The 1891 Belcourt Castle, in the style of a King Louis XII castle, is alleged to be haunted by a brown-robed monk. *Newport Chamber of Commerce.*

Opposite, bottom: The magnificence of the Breakers crowns the Newport cliffs overlooking the Atlantic Ocean. *Newport Chamber of Commerce.*

Aquidneck Island and the Founding of the Ocean State

some thirty servants at Belcourt, with aggregate wages of approximately $100 per week.

Constructed in a multitude of European styles and periods, Belcourt is designed with heavy emphasis on French Renaissance and Gothic décor, with further borrowings from German, English and Italian design. The building is formed of a large quadrangle, with two-story wings connecting to a three-story main block (the north wing). The effect today is in the form of a large, eighty- by forty-foot central courtyard with half timbers in the Norman style.

The Breakers

This most grand of the Newport palaces, built in 1895 for Cornelius Vanderbilt, rivals the Italian Renaissance palaces after which it is modeled. The symmetry of design, opulence and lavish use of alabaster, marble, mosaics and carved antique wood would prohibit its construction today.

The Breakers is the sum of all Gilded Age houses; the monumental four-story limestone palace measures 250 by 150 feet, enclosing seventy rooms of imperial grandeur. The structure's footprint covers nearly an acre of the Vanderbilt's eleven-acre estate on ochre Point.

The Elms

This magnificent estate was built in 1901 for Edward J. Berwind, a Philadelphia and New York coal entrepreneur. Architect Horace Trumbauer modeled the Elms after the early eighteenth-century Chateau d'Asnieres near Paris. The extensive grounds boast a formal sunken garden designed by French landscape architect Jacques Greber, including terraces, teahouses, statuary, fountains and a wide variety of specimen trees.

Berwind and his wife, Herminie Torrey, the daughter of the English consul to Italy, lived in a small Newport Victorian cottage since 1888. Berwind, in anticipation of building a grand summer retreat, enlarged his Bellevue Avenue estate by fourteen acres.

Aquidneck Island and the Founding of the Ocean State

The Elms Mansion on Bellevue Avenue is one of Newport's great estates. The house was built in 1901 for Edward J. Berwind of Philadelphia and New York. The extensive grounds are a showplace of terraces, teahouses, classic statuary, fountains and a wide variety of specimen trees. *Newport Chamber of Commerce.*

MARBLE HOUSE

Designed in the Beaux Arts style by Richard Morris Hunt, Marble House was built between 1888 and 1892 for William Kissam Vanderbilt, grandson of Cornelius Vanderbilt. It is one of the most sumptuous buildings ever raised on American soil. The house was a social landmark that helped spark the transformation of Newport from a relatively relaxed summer colony of wooden houses to the now legendary resort of opulent stone palaces.

Lavish use of marble and gilding contributed to the mansion's $11 million cost ($260,000,000 in today's dollars) of which $7 million went to the purchase of 500,000 cubic feet of marble.

Vanderbilt gave the house to his wife, Alva Erskine Smith, as her thirty-ninth birthday present. After the Vanderbilts divorced in 1895, Alva married

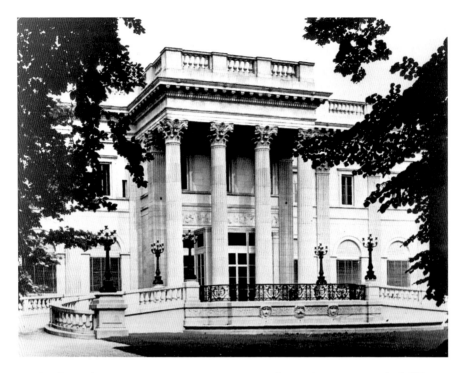

Marble House is an 1892 gem designed by architect Richard Morris Hunt for William K. Vanderbilt. Hunt made lavish use of marble and gilding throughout the building, making this one of the most sumptuous residences ever raised in America. *Newport Chamber of Commerce.*

Oliver Hazard Perry Belmont, moving down the street to Belcourt Castle. After Belmont's death, she reopened Marble House and added a Chinese Tea House on its seaside cliffs, where she hosted rallies for women's suffrage.

ROSECLIFF

The heir to a Nevada silver fortune, Theresa Fair Oelrichs commissioned this Bellevue Avenue residence overlooking Cliff Walk and the Atlantic Ocean in 1899. The architects, the esteemed New York architectural house of McKim, Mead & White, took their inspiration from the Grand Trianon at Versailles. This structure features the largest ballroom in Newport.

Aquidneck Island and the Founding of the Ocean State

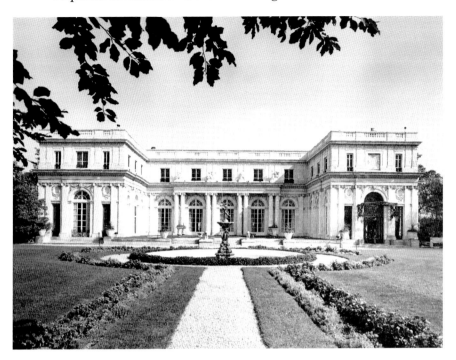

Rosecliff was built in 1899, overlooking Cliff Walk and the Atlantic Ocean the house features the largest ballroom in Newport. *Newport Chamber of Commerce.*

After the house was completed in 1902, at a reported cost of $2.5 million, Mrs. Oelrichs hosted fabulous entertainments here, including a fairy tale dinner and a party featuring famed magician Harry Houdini.

Scenes from several films feature Rosecliff as their location, including *The Great Gatsby*, *True Lies*, *Amistad* and *27 Dresses*.

12

Lifesaving and Lighthouses[28]

Lifesaving Stations

The first stations of the Rhode Island branch of the United States Volunteer Life-Saving Service (USVLSS), organized in 1904, were built in Newport.

We learn the following interesting facts from the USVLSS 1909 report to the Rhode Island General Assembly:

> *The greater part of the 73 drownings that occurred in Rhode Island in 1908 happened in inland waters, not in tidewaters. For the years 1904 through 1907, the Rhode Island branch of the USVLSS reported a total of 274 drownings and 141 rescues. This number represents the total for both inland and ocean waters. The Service reported that of the drownings in saltwater, a large portion was from circumstances unknown, which included a large percentage of suicides.*

Newport District

This district includes stations at Twerton, Portsmouth, [Bristol] Ferry Landing, Newport Harbor, Fort Adams, Jamestown, Fort Greble, St. George's School, Newport Yacht Club and such new stations as may be later organized in this vicinity. Block Island is for the present included with this district.

Historic Tales of Colonial Rhode Island

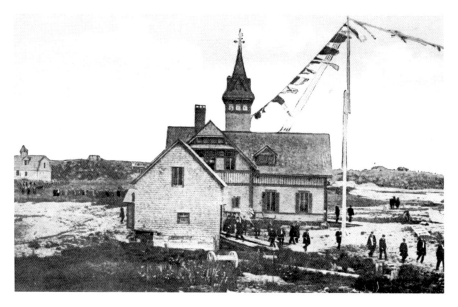

The Rhode Island branch of the United States Volunteer Life-Saving Service was organized in 1904. The stations in Newport were among the first built and manned.

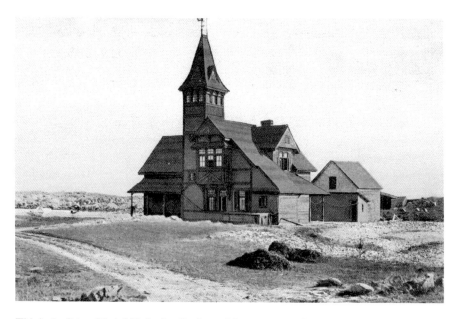

This is the Prices Neck Life-Saving Station at Newport around 1908. Through the years 1904 to 1907, the service reported on the drownings in salt water; a large number were thought to be suicides.

Aquidneck Island and the Founding of the Ocean State

Newport Sub-District

The district has been well inspected by the headquarters launch in charge of the superintendent and the quartermaster. Active work has been rather quiet at Sakonnet River as far as drilling of crews is concerned; but members have been onto their job, and so has the apparatus. At Newport Harbor, under the care of Captain George Brown, of Long Wharf, the apparatus had been repainted and inspected, excepting at Fort Adams, and is in good condition to render assistance when needed. At Easton's Beach, where the work has been under the care of Theodore Cookingham and Coxswain Charles Gunther, considerable work has been done, and the assistance of Mr. Aekerman, at the upper end, has been of value. Owing to the hostility of Mr. Fred Pain, public demonstrations were not practicable, as he told the superintendent he did not want the bathers taught to swim or instructed in life-saving methods. "It interferes with our routine," he said, "and our routine must be maintained." However, the lifeguards were given instruction, which was of value to them through the season, in attending persons who were in danger, and similar demonstrations were given for the benefit of lifeguards, bathing house employees and some patrons at Spouting Rock [at Bailey's Beach]. *During a large part of the season, a dory was kept at the beach for emergencies, and provided its excellence as a surfboat on a number of occasions.*

NEWPORT RESCUES

In the fall of 1907, Captain Triksel, of the launch Pauline *was pulled out by the USVLSS buoy at the Newport Yacht Club. He fell overboard from his boat on the anchorage. The case was not reported until the 1907 report went to press.*

May 16, William Burns, an engineer employed by the Newport Coal Co., who lives at 15 Elm Street, Newport, heard cries of a small boy who was sinking in the harbor. He jumped in, and brought him safely to shore.

Woodward Phelps, the 6-year-old son of Lieutenant Commander W.W. Phelps, USN, fell from the wharf at Newport, on August 1, and was rescued by Chief Master at Arms Robert Conklin, who chanced to be nearby.

Four young men from Falmouth, Mass., were rescued from a burning launch in Newport Harbor by the men from Fort Adams, on August 6.

Miss Flora Scheer, of Jamaica Plains, Mass., was rescued from drowning at Easton's Beach by Michael Barrett, a member of the USVLSS, but died, after her recue, from heart failure.

Four sailors were rescued in Newport Harbor on August 28, 1908, by Charles Schoeneman, of Goat Island Light. The sailors had been to Newport, and were endeavoring to return to the Naval Station when their small boat swamped.

On August 31, 1908, Earl Weeden and Grederick Murran rescued Ralph Atwater from drowning in Newport Harbor.

Three sailors from Fort Adams were rescued by a party of nine people in a sailboat, who say the men were trying to climb up the stone wall of the pier at the fort, after having been dumped into the water by the capsizing of a rowboat.

On September 29, Mrs. H. Livingston Beeckman waded into the water and rescued two men, named Allen and Norbury, from drowning. The men had been fishing in a small boat, when it capsized.

May 20, [the] corps launch *[the]* Colonel *proceeded to Rose Island lighthouse, Newport Harbor, and the superintendent presented to Keeper Charles S. Curtis his double-barred bronze medal of honor for saving two lives off the light in 1905 and 1906. Captain Curtis said he was proud to wear the medal, and that he would cherish it and hand it down to his children.*

[A] Medal was presented to Leonard O. Ritter, at national Headquarters, June 29, by State Superintendent Longfellow, assisted by the General Superintendent. Ritter went through the ice at Eastons Pond, at Newport, and recovered the body of the lad who went through the ice.

Newport Lighthouses

The most important aid to navigation, second only to the U.S. Coast Guard, is the National Lighthouse Board, which came into existence in 1852. Before this date, the nation's coasts were substandard compared to those of other seafaring nations. Sadly, our coasts were inadequately marked; the light towers were poorly constructed and maintained, and their keepers were poorly trained political appointees.

Aquidneck Island and the Founding of the Ocean State

All that changed when the board came into being, with a committee that understood the importance of well-trained and dedicated keepers in the service of well-maintained lighthouses, beacons, fog signals, buoys and lightships.

In this section, we explore the origins of three well-known Newport lighthouses.

The Goat Island Lighthouse

From its founding, Newport established itself as an important gateway to the Atlantic Ocean, the West Indies (Caribbean), England and Africa. The entrance to Newport Harbor only received its guiding beacon in 1823.

The octagonal light tower's outer walls were constructed of granite; the interior walls were lined with chisel-textured stone and a stone spiral stairway leading to the lantern room. The original structure continued on duty until the new structure was ready in 1842. Between 1852 and 1856, the government appropriated money for the maintenance of the Goat Island Lighthouse and for building a dike wall and a beacon light for Seine Rock in Newport Harbor. In 1864, a new keeper's house was built next to the tower.

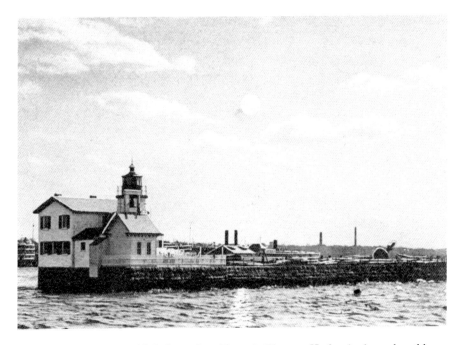

The Goat Island light and light keeper's residence in Newport Harbor is pictured on this 1909 postcard.

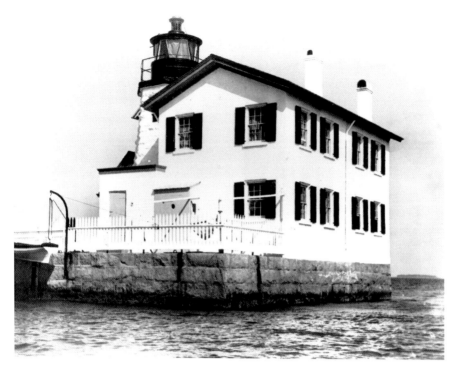

The Goat Island light keeper's house was demolished in 1923 after being damaged when a submarine ran aground on the island.

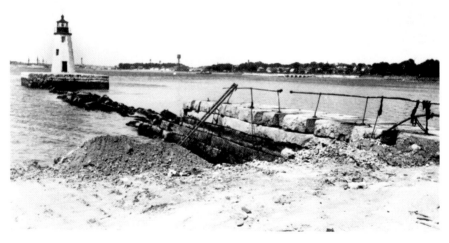

The Goat Island light as it now exists. The granite wall on the right in this photo is the foundation of the original lighthouse. As the physical plant of the torpedo station expanded during the 1890s, the sea wall was extended 1,600 feet across the mud flats with cinders from the station's power plant to the new lighthouse on the northern tip of the island.

Aquidneck Island and the Founding of the Ocean State

In 1873, a fog bell and machinery automating the bell were installed. Beginning in 1906, the beacon's characteristic light was flashing white for fifteen seconds, followed by five seconds of darkness.

The long-established Goat Island light keeper's house was razed in 1923 after damage caused by a submarine that ran aground.

The new light tower now stands alone on a granite foundation. The original light tower, the oldest surviving in the state, a unique example of a small early nineteenth-century light, was dismantled and removed from Goat Island in 1851 and now stands at Sandy Point on Prudence Island.

The Goat Island Lighthouse is an active aid to navigation; it is now fully automated (that occurred in 1963).

Completely restored by the U.S. Coast Guard in 1989, and now referred to as the Newport Harbor Lighthouse, it is listed on the National Register of Historic Places.

Castle Hill Light

At the westernmost point of Newport, at the entrance to Narragansett Bay's east passage, is Castle Hill. At this site in 1740, there was a watchtower built for scanning the horizon for pirate ships.

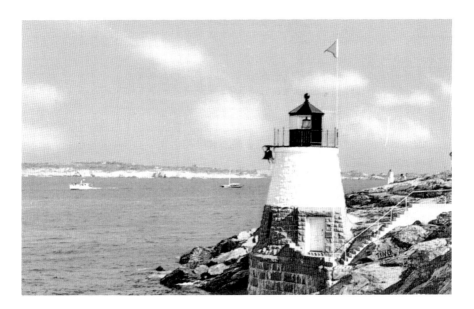

The Castle Hill light is located in the southwestern end of Newport Harbor.

In 1869, the federal Lighthouse Board determined the need for a lighthouse and fog signal at this particular site. In 1875, the government made an unsuccessful offer of $10,000 to landowner Alexander Emanuel Agassiz. Agassiz was a wealthy industrialist, making his fortune in a mining company.

The Lighthouse Board resurrected the Castle Hill proposal in 1886 for a modern aid to navigation lighthouse. Agassiz was again approached for the sale of his harbor-side land. This time, imbued with the warmth of a benefactor willing to do a good deed for the good of the city and state, in June 1887 he gave a two-acre piece of his property to the government for one dollar.

Architect H.H. Richardson was contracted to design the new lighthouse. Richardson is noted for his design of Boston's Trinity Church and the Buffalo, New York State Hospital. Newport contractor William T. Wilbur was the builder. The thirty-four-foot-tall granite lighthouse clinging to the rugged Castle Hill cliff is constructed of rough-hewn granite with rich chiseled texture. The lighthouse was first illuminated in May 1890 with a flashing red light visible for ten nautical miles.

The Lime Rock Light

A cluster of limestone ledges about nine hundred feet from the southern shore of inner Newport Harbor, forming a small rugged island, posed a significant hazard to waterborne traffic. By the mid-1800s, Newport Harbor had seen a great increase of boating—military, commercial and pleasure—giving concern to town authorities for their safety.

On March 3, 1853, Congress appropriated the sum of $1,000 for placing a warning light on this pile of lime rocks.

Hosea Lewis, a pilot in the U.S. Revenue Cutter Service, became the first keeper on November 15, 1853. Until 1857, when the keeper's house was built on the diminutive island, the keeper had to row from shore to maintain the light. The new two-story, hip-roofed brick house is similar to other light keepers' houses built around Narragansett Bay. The light tower is a narrow, square brick column attached to the building's northwest corner. Access to the tower light is through a second-story niche in the house.

The Lewis family took residence in their offshore home in the early summer of 1858. Shortly after, Hosea Lewis suffered a stroke, paralyzing him. Unable to fulfill his duties, his wife took over. In 1872, she received the

Aquidneck Island and the Founding of the Ocean State

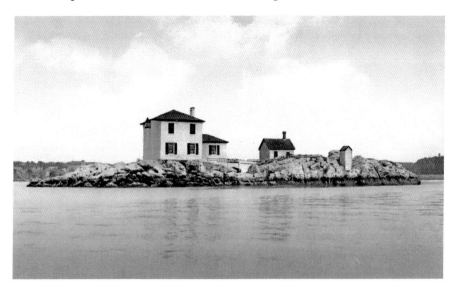

The original Lime Rock light was built in 1854. The light has been inactive since 1927.

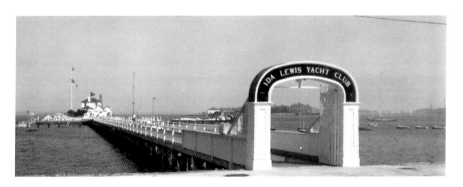

Entrance to the celebrated Ida Lewis Yacht Club. A lantern mounted in one corner of the two-story granite-and-brick keeper's house is lit as a decorative light during holidays.

title of official keeper. The Lewises' young daughter, Idawalley, assisted her mother in tending the light.

After the deaths of her parents in 1872, Ida Lewis became Newport Harbor's Lime Rock Lighthouse keeper until her death in 1911.

Ida Lewis, sometimes referred to as the "Grace Darling of America," was born in Newport. At age fifteen, she moved with her family to the Lime Rock Lighthouse.

It was the custom of the soldiers from Fort Adams to row to Newport across the harbor. Several times during these rowing excursions, on dark

and stormy nights, their boats capsized, throwing them into the water. Their cries for help were answered promptly by Miss Lewis.

So often did her heroic rescues become known that she received many medals and trophies. The grateful citizens of Newport presented her with a specially built rescue boat, of which she was extremely proud. Her medals and citations can be seen at the Newport Historical Society.

In 1924, the Rhode Island General Assembly officially changed the name of the tiny Lime Rock Island to Ida Lewis Rock. In 1928, the island and lighthouse building became the property and clubhouse for the Ida Lewis Yacht Club. The club's burgee honors Lewis with eighteen white stars and a lighthouse emblazoned against a red background representing the eighteen lives she saved. It is possible the number of lives she saved was as many as thirty-five; the modest woman kept no official records of her lifesaving exploits.

Visiting yachtsmen know the club for its hospitality, however small and unpretentious it might be.

13
A Nineteenth-Century Newport Timeline

The life and growth of a community is reflected in its citizens and their pursuits. Modern-day Newport is the result of diverse individual and societal endeavors. The early history of colonial Newport from the time of its founding in 1639 through the eighteenth century is covered in other chapters of this book. In this chapter, you will learn many of the important and seemingly trivial events forming the character of twenty-first-century Newport.

1819: In June, a small group of citizens met to organize a savings bank. A meeting was held on June 12 at the old statehouse for the purpose of petitioning the General Assembly for a charter.

At a town meeting, a resolution to divide the town into five wards, with representatives from each forming a town council, received a unanimous favorable vote.

In those days, mail came to town by packet and stagecoach at a cost of six cents paid by the recipient. However, some of the boys in the town met the packets, collected the mail, delivered it and collected twenty or fifty cents per item delivered. In order to circumvent these budding entrepreneurs, the postmaster ordered that all mail must bear the stamp of the post office and the fee be paid to authorized collectors only.

1820: Bannister's Wharf was the center of shipping activity. Ships arriving from foreign ports made this their first port of call. The voyage from London was usually made in thirty-five days, weather permitting.

The Newport population for this year was 6,763 of whites, 539 free colored[29] and 17 colored slaves—a total population of 7,319.

1821: The custom of the day to raise funds for various purposes was a system of lotteries. The lottery system had the blessing of the General Assembly, which encouraged the practice for the purpose of furthering the domestic industry of the state.

A serious epidemic of yellow fever broke out in many cities along the Atlantic coast, and a strict quarantine was enforced in Newport for ships arriving from infected ports.

A private reading and writing school was opened by John Rodman at 8 School Street. Rodman accepted carpentry and mason work as tuition payment.

1822: The first steam-driven passenger boats made their appearance in Newport Harbor. The *Connecticut* and the *Fulton* made twice-weekly round trips between Newport and New York.

1823: The first steam vessel built in Newport was a small one. Its engine was designed by John Babcock. This boat ran between Newport and Providence.

Rapidly increasing retail businesses advertised a wide selection of articles, including whale oil, sperm candles, rum, straw and beaver hats and many sundry goods imported from London.

1824: Newport Harbor and Narragansett Bay played a prominent part in the early history of the town. This year, construction of Fort Adams began. Hundreds of laborers and mechanics were employed; the payroll was a material help to the merchants of the town. The fort mounted 648 guns of various sizes, and with its granite and brick walls, it was considered the most formidable fortification in the world.

1825: Newport's fame as a summer resort had been spreading for several years, with men of means visiting from the southern United States. Returning year after year, they brought their families to luxuriate in the town's natural beauty and healthful sea-air climate.

With the continuing influx of summer visitors, the town's hotels and boardinghouses did a thriving business. To accommodate the most wealthy summer visitors, elegant Victorian hotels with wide, sheltered verandas affording grand ocean views were built.

Aquidneck Island and the Founding of the Ocean State

1826: At a town meeting held in the statehouse, councilors voted to sell the land known as Gallows Field. The funds realized from the sale and the sum of $600 from the town treasury were used to build the schoolhouse on Mill Street.

President Adams visited Newport in November for the express purpose of inspecting the fortifications at Fort Adams, which bears his name.

In December, the sloop of war *Lexington* arrived in Newport with the remains of Commodore Oliver Hazard Perry, who died in Trinidad in 1819. His burial in the Island Cemetery was accompanied with great pomp and military honors. A tall granite shaft marks the grave site.

1827: The U.S. Army Artillery Company stationed at Fort Wolcott left Goat Island for a new post in the South, leaving only a caretaker at the fort.

1828: The Bellevue Hotel opened to receive summer visitors. The new hotel, featuring luxurious accommodations, proved to be a popular addition to the hotel life of the town.

During the summer, the First Light Infantry Company of Providence arrived on the steamboat *Fulton*. The soldiers were met at the pier by the Newport Independent Volunteers and escorted to the campground, where they went through several days of training before returning to Providence.

1829: The steamer *President* made its first trip from New York to Newport, replacing the *Fulton*.

The old Newport Theatre, operating as early as 1793, welcomed many New York and Boston theatrical companies, presenting a list of plays received with great interest by the citizens.

1830: The Newport Artillery Company conducted a lottery to raise funds to build a suitable armory.

The construction of Fort Adams was ongoing at this date, and the government was advertising for additional material, including 500,000 bricks and two thousand pieces of granite.

The town's population was now 8,013.

1831: Newport could never claim to be a manufacturing city, although an early attempt was made to manufacture cotton goods. During this year, the so-called Old Stone Factory was built and operated until 1857.

1832: Counterfeit money made an appearance in Newport, and its circulation was state-wide. The spurious money consisted of one- and five-dollar bills. It is said the bills were clever copies of the bank notes then issued by local banks.

Congress ordered a survey made in Narragansett Bay with the view of selecting a suitable location for a naval base.

1833: A new customhouse was built on the corner of Thames Street and what was then King Street. A bust of Benjamin Franklin was placed on the building, and the street's name was changed to Franklin Street.

In June, President Andrew Jackson and Vice President Calhoun visited Newport. They remained in town for several days, being entertained by some highly placed citizens.

1834: On May 20, General Lafayette died. The news arrived in Newport from London on June 20. The government ordered a state of mourning at all army posts. At Fort Walcott, a salute of twenty-four guns was fired at daybreak and one gun every half hour until sunset.

The regular army of the United States was composed of 6,412 officers and men, and the militia numbered 1,316,615 men.

1835: Deposits in the Newport Savings Bank amounted to $70,975.59.

This year, the Perry Cotton mill was built. It contained about eight thousand spindles, and during peak production it employed 125 people.

1836: The whaling ship the *William Lee* was completed this year. It was the last of several built in Newport.

1837: On February 20, the following ships brought merchandise into Newport: the brig *James Clark*, fifty-five days from Africa, brought ivory, furs and sundry goods; the brig *Mary Cole*, thirty-nine days from Mobile, came with a mixed cargo; the brig *Overman*, twenty-one days from Mobile, delivered cotton for the local mills; and the brig *Sea Bird*, fifteen days from New Orleans, brought molasses for local distilleries.

1838: Overland transportation between Newport and Boston by stagecoach left Newport at 9:30 a.m., arriving in Fall River at 12:30 p.m., in Taunton at 4:30 p.m. and in Boston at 6:30 p.m. Returning, the coach left Boston at 7:00 a.m., arriving in Newport at 4:00 p.m.

Aquidneck Island and the Founding of the Ocean State

1839: The town celebrated the 200th anniversary of its settlement.
 The commissioner of streets was authorized to take a loan for $1,500 for improvement of streets and highways.

1840: The sum of $7,500 was raised by taxation to meet expenses for the coming year.
 The committee for schools reported attendance of 628 pupils.
 The town census showed a population increase of 308, for a total of 8,321 residents.

1841: All public buildings were draped in black at the news of the death of President William H. Harrison.
 The *Newport Mercury* celebrated its eighty-third year of newspaper publishing.
 Fort Adams was finally completed, and the first garrison of two companies of troops arrived on August 25.

1842: This was the year of the so-called Dorr Rebellion. Dorr and a small group of followers attempted to overthrow the constitutional government of the state. The Newport Artillery was ordered to Providence. It left town with full ranks. In a few days, the rebellion collapsed, and the artillery returned without firing a shot. Dorr fled to Connecticut.

1843: Coal mined in Portsmouth was sold in Newport. The mine yielded large amounts of the fuel, but as fuel, the coal was unsatisfactory because of poor combustibility. The local joke was: in case of a disastrous fire, people should take shelter in the coal mine because it was flameproof.

1844: As the hotel and cottage life of the town expanded, there grew a demand for increased hotel accommodations. The Ocean House Hotel on Bellevue Avenue was built, and later in the year the Bellevue Hotel was enlarged and improved.

1845: The Ocean House Hotel was short lived; it was totally destroyed by fire. Fortunately, all three hundred guests escaped without injury.
 The First Baptist Church on Spring Street was completed. Its first pastor was Reverend Dr. John Clarke.
 At a town meeting, citizens discussed the possibility of building a steam railroad between Newport and Fall River.

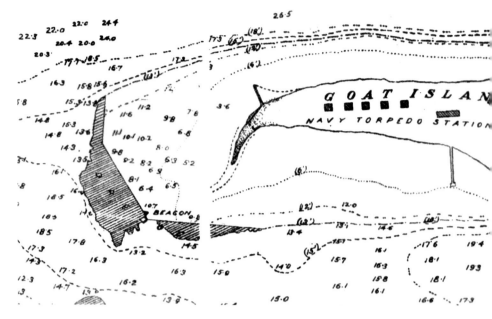

This abridgement of a larger July 31, 1884 Newport Harbor map features an image of Goat Island. The greater map shows harbor depths and the Newport shoreline. It was submitted to the U.S. Army chief of engineers by Edgar H. Elliot, lieutenant colonel of engineers.

1846: The first daily newspaper published in town, the *Newport Daily News*, appeared on May 4, 1846.

The rebuilt Ocean House Hotel opened for the summer. It was the center of social activity.

1847: A daily ferry service running during the summer months brought visitors from New London, Fall River and Providence. It was estimated that during August, in excess of two thousand visitors were staying at the hotels and boardinghouses.

The Central Baptist Church on Clarke Street was finished and opened for services.

1848: The new hand-fire engines were housed at the uptown and downtown fire houses; the engines were usually purchased by time payment and manned by volunteer crews of forty to fifty men.

Aquidneck Island and the Founding of the Ocean State

1849: With the discovery of gold in California, seventy-four Newporters sailed for San Francisco.

Henry Clay visited Newport, staying at the Atlantic House. This hotel, popular with the traveling public, was situated on the site now occupied by the Elks Club.

1850: After considerable debate, a telegraph company was allowed to come to town. Poles were erected on Thames Street, and service began.

A new hotel named the Veranda was built on Pelham Street.

1851: President Millard Fillmore came to town and made his headquarters at the Bellevue Hotel on Catherine Street.

The ship *John Alfred Hazard* was launched from the Silas Cottarell yard and fitted for the West Indies trade.

1852: Prior to this day, Bellevue Avenue below Narragansett Avenue consisted of farmland. With the continuation of the street to Bailey's Beach, large tracts were now available for home building.

1853: Many years before Newport experimented with gas in 1817, David Melville successfully lit his own dwelling and a portion of Pelhan Street. In August 1852, pipes were laid along Thames Street by the Newport Gas Light Company, and the street was illuminated later in the month.

1854: Judah Touro, in his will, made a bequest to the City of Newport of $10,000 to purchase the lot on which the Old Stone Mill stands as a public park for the benefit of the citizens.

1855: The cornerstone of the United Congregational Church on Spring and Pelham Streets was laid.

1856: The gas company extended its pipes to include Long Wharf.
The first city directory was published by William H. Boyd.

1857: A new hand engine was purchased for the Aquidneck Fire Company No. 3. It required from thirty to forty-four men to operate the pump.
The Gas Company extended its mains to Bellevue Avenue as far as the Wetmore estate.

1858: The funeral of Mrs. Oliver Hazard Perry, wife of Commodore Perry, took place. Three Newport men who served with Perry at Lake Erie offered their respects.
The *Newport Mercury* celebrated its 100th anniversary of publishing.

1859: The population of Newport was now about ten thousand.
A new pavement replacing the old 1767 cobblestone walk was laid on Thames Street.

1860: The Codington Mill was destroyed by fire and never rebuilt.
Ocean Drive was extended from Brenton's Neck along the shore to Bateman's Point.
Taxpayers numbered 1,698. The total valuation of real and personal property was $10,930,500.

1861: Civil war was declared. The Newport Artillery left for Providence and joined the First Rhode Island Regiment. Company F from Newport took part in the Battle of Bull Run.

Aquidneck Island and the Founding of the Ocean State

On May 8, the frigate *Constitution* came to Newport.

The city council conveyed land to the Old Colony & Fall River Rail Road Company.

1862: The last Newport-based whaling vessel, the *William Lee*, was sold.

The school enrollment was 1,079 students and twenty-seven teachers.

The city's tax assessment was $60,998.76, with 124 cottages or homes owned by residents of other cities.

1863: Work began on the fort at Dutch Island.

The steamer *City of Newport* was completed for the Providence Line.

More summer homes were being built along Bellevue Avenue by out-of-towners. Construction contracts for January and February amounted to $240,531.

1864: The telegraph line was now connected to Providence.

A movement in favor of horse cars was started, but it met with little encouragement.

The Van Ambunch Circus & Menagerie presented an entertainment on the circus grounds on Spruce Street.

A flower mill was operating on Swinburne's Wharf, producing one hundred barrels daily.

Property values were rapidly increasing; the valuation on real estate was now $11,009,300. Personal property value was $5,406,200, with a tax rate of $6 per $1,000.

1865: The Lovell Hospital at Portsmouth Grove (Melville), operating for three years caring for Union and captured Confederate soldiers, closed early in the year.

In July, the Naval Academy returned to Annapolis.

The city census numbered a population of 12,701, an increase of 2,181 in five years.

1866: The Home for Friendless Children opened on the corner of Mary and School Streets.

The Academy of Music opened with a gala concert.

The Atlantic House introduced roller skating, which became a popular pastime.

Citizens voted to purchase a steam fire engine.

Newport now counted 1,909 houses and 2,549 families, contrasting with Jamestown, with only 76 houses.

1867: Tax valuation of both real and personal property was $18,980,100.00, assessed at $151,840.80.

Steam Fire Engine No. 2 was housed at the station at the corner of Touro and Mary Streets.

The first free library was established.

1868: August Belmont and his wife presented the city with a bronze statue of Commodore Mathew Perry, brother of Commodore Oliver Hazard Perry, father of Mrs. Belmont. Fitting ceremonies accompanied the October dedication of the statue at Touro Park.

1869: Goat Island was occupied by the U.S. Navy as an experimental torpedo station.

In August, President Ulysses S. Grant visited the town.

1870: The machine shop was built at the torpedo station, and employment was twenty-four men.

A new People's Library was established on Thames Street through the generosity of Christopher Townsend.

1871: The Newport and Wickford Railroad and Steam Boat Line opened, providing better travel facilities between Newport and New York.

The school department reported an attendance of 1,401 pupils.

1872: William Sanford Rogers left a bequest of $100,000 to endow the Rogers High School.

1873: The Newport Hospital was incorporated and opened on November 22.

The city added $50,000 to the bequest made by Mr. Rogers. The Rogers High School on Church Street opened.

1874: More new buildings and improvements were underway on Thames Street than in the past fifty years.

The Atlantic House was closed, never to reopen.

Paid firefighters were now employed by the city.

Aquidneck Island and the Founding of the Ocean State

Cottages for naval officers were built on Goat Island.
The first steam roller arrived in Newport.

1875: The most brutal winter weather in memory closed the harbor to shipping.

1876: Polo was now the most fashionable sport by the summer colony.
Traffic was so heavy on Bellevue Avenue that mounted police were patrolling the thoroughfare.
Horse-drawn buses were running on Broadway, Spring Street and Bellevue Avenue.

1877: President Rutherford B. Hayes paid a visit to Newport.
A daily mail service was now operating between Newport and Block Island.
In September, the Newport Steeple Chases were held at a track laid out on Sachuest Point.

1878: The work of the water company had progressed to the building of a dike at Easton's Pond, a reservoir and pumping station being built and water pipes being laid on Thames Street.
The Ochre Point district was becoming popular for summer residences. Pierre Lorillard's home was built.

1879: The Unitarian Committee purchased land on Pelhan Street for the site of a new church. The old church on Mill Street was still in use. Its history dates back to the Revolution.

1880: The first cable to Block Island was laid.
The Newport Casino was now open and was liberally patronized by the summer colony.
Coaster's Harbor Island, longtime asylum for Newport's poor, was ceded to the government for establishing a naval training station.
The first tennis tournament was held on the courts at the Newport Casino.

1881: The Channing Memorial Church was completed and dedicated.
The naval training station was formerly opened with the arrival of six hundred recruits.

1882: President Chester A. Arthur spent some time in Newport; he attended the polo games and fox hunts. Free postal delivery was introduced.

A new hook and ladder truck was received, replacing the old one, which had seen twenty-one years of service.

The first electric streetlights were illuminating Thames Street and Bellevue Avenue. The dynamo generating the energy was located in the Swinburne mill.

1883: The several hotels now operating in Newport included the Kay Street House, the Aquidneck, Perry House, Unites States, Ocean House, Cliff Avenue Hotel and Bateman's.

Games of baseball were becoming popular, and several local teams were active.

1884: The Naval War College was established this year.

1885: On September 10, the anniversary of the Battle of Lake Erie, the statue of Commodore Oliver Hazard Perry was dedicated on Washington Square.

1886: The Honorable Levi P. Morton deeded his land at the lower end of Spring Street to the city for use as a public park.

In August, the summer colony staged the first four-in-hand coach parade on Bellevue Avenue.

The city's real estate valuation was now $28,540,310.00, and the tax rate was $10.50 per $1,000.00.

1887: The first private home lit by electricity was that of Joseph Tuckerman, a resident of Mill Street.

The 1887 directory listed 8,095 names, of which 550 were summer residents.

1888: The Incandescent Electric Light Company, with a plant on Codington Wharf, was awarded the electric light contract by the city.

The new excursion steamer *Mount Hope* made its first appearance in Newport.

The popular sound steamer *Bristol* burned to its waterline at the Long Wharf dock.

The Newport Savings Bank reported deposits amounting to $5,676,289.44.

1889: The steamer *Puritan* made its initial voyage to New York.

President Benjamin Harrison visited Newport; he held a reception in the old statehouse.

The fire department purchased several new horses.

1890: A new pavilion was built at Bailey's Beach, the popular playground of the "Four Hundred."

The Edison Illuminating Company constructed a new power plant at Tews Court to supply the city and streetcar line with electrical current.

The Aquidneck Pure Ice Company began the manufacture of artificial ice at its Perry Mill location.

A new schoolhouse was dedicated on Calvert Street.

1891: The Newport Artillery Company celebrated the 150th anniversary of its founding.

The St. Joseph Parish parochial school was dedicated.

The city census for this year numbered the population at 19,457.

1892: William K. Vanderbilt's marble palace was still under construction; it would have been completed before this date except much of the interior finish, being prepared in New York, was destroyed by fire.

On November 25, the palatial residence of Cornelius Vanderbilt, called The Breakers, was completely destroyed by fire.

The *Newport Herald* began publishing on March 23, under the management of the Herald Publishing Company, with Horace B. Allen, editor. Prior to this, in 1888, another morning paper, the *Newport Daily Observer*, was published by Frank G. Harris and continued until 1894, when it was absorbed by the *Herald*.

1893: The bronze statue of William Ellery Channing was unveiled on Touro Park. The gift of William G. Weld was the work of W.C.N.

1894: The state armory on lower Thames Street was occupied jointly by the recently organized naval reserve and the Newport Company of the U.S. National Guard.

On the afternoon of July 14, a storm swept over the center of the city, pelting buildings with hailstones as large as eggs. In eight minutes, thousands of panes of glass were broken, and much damage was inflicted on livestock and vegetation.

A telephone cable now connected Newport to Jamestown.

Old Fort Dumpling on Conanicut Island (Jamestown) is believed to have been built by the British. Fort Dumpling is mentioned in a 1778 correspondence addressed to British general Pigot.

Aquidneck Island and the Founding of the Ocean State

1895: During the annual cruise of the New York Yacht Club, the city was gaily decorated and illuminated. Fireworks displays on the waterfront attracted thousands of visitors. All the yachts took part in the illumination, and the searchlights of the war ships added to the spectacle.

1896: The U.S. Navy gunboat *Newport* was launched in Bath, Maine.

The steam ferry *Beaver Tail* arrived for service.

The sprouting Rock Beach Association was incorporated, purchased Bailey's Beach and began its development as a private beach.

1897: Many new summer residences were being built, giving employment to large numbers of local contractors.

In August, the North Atlantic Squadron visited Newport, and a full week of entertaining and celebrations took place.

The arrival of the New York Yacht Club fleet was followed by an upswing of business for the merchants on Thames Street, as stewards from the yachts replenished their supplies.

On October 16, the gunboat *Newport* arrived in port, and a silver service was presented to the ship by the citizens of Newport.

1898: War with Spain was declared. The Newport Artillery was ordered to Fort Adams. The harbor was mined. The naval reserve company departed to man the monitor *Ajax*.

The Newport and Fall River Electric Railroad was completed and began service.

On September 9, the Ocean House was destroyed by fire. Long the center of hotel life and the scene of many festive entertainments, the loss of the Ocean House ended a phase in the life of the old city by the sea.

Another familiar landmark was lost when the government removed old Fort Dumplings to make way for modern fortifications on Jamestown.

1899: The war with Spain ended. The Atlantic Fleet returned to Newport with Admiral Sampson in command, fresh from their victory over the Spanish fleet in Cuba.

Newport voted to erect a new city hall at the corner of Broadway and Bull Street.

The first automobile parade was held.

1900: This year, Newport ceased being one of the capitals of Rhode Island.

The first auto races were held at Aquidneck Park in Middletown using the horse racetrack for the course. Some of the cars reached the breakneck speed of twenty miles an hour.

NOTES

INTRODUCTION

1. Green, *Providence Plantations*, 432.
2. Ibid., 433.

CHAPTER 1

3. *Antinomianism*: The heretical doctrine that Christians are exempt from the obligations of moral law. Possibly the most noteworthy instance is that of the Plymouth Brethren, of whom some are quite frankly Antinomian in their doctrine of justification and sanctification. It is their constant assertion that the law is not the rule or standard of the life of the Christian. (Source: *The Catholic Encyclopedia*.)
4. He later moved his headquarters to Overing Farm in Portsmouth. For more on General Prescott, see the story of William Barton's raid in my book *Tiverton & Little Compton: Historic Tales* (Charleston, SC: The History Press, 2012).
5. The exact time of Fort Dumpling's construction is in doubt.

CHAPTER 2

6. Letter of marque is a privateer commission, in effect a license for piratical actions on the sea.
7. "Persons now living…," circa 1880.

Notes

8. "Plate ship" is possibly a reference to silver plate.
9. Suggested reading for an in-depth story of the life and adventures of Captain William Kidd is Richard Zacks, *The Pirate Hunter* (New York: Hyperion Books, 2002).
10. The largest single endowment to the Greenwich Hospital School, Holbrook, Suffolk, United Kingdom, came from the forfeited New York estate of the Captain William Kidd (1645–1701), after he was convicted of piracy and hanged. The estate amounted to £14,000, an immense fortune for the time.
11. For more on the Wanton family, see my book *Tiverton & Little Compton, Rhode Island: Historic Tales of the Outer Plantations* (Charleston, SC: The History Press, 2012).

Chapter 3

12. Fort George on Goat Island in Newport Harbor.

Chapter 4

13. These two parallel roads are now called East Main Road and West Main Road.
14. John Sullivan, the eminent soldier, was one of the leading men of the First Congress, who not only became a great military leader but also won fame as an able public official. He was the third son of Owen Sullivan, of Limerick, Ireland, and was born in Somersworth, Strafford County, New Hampshire, on February 18, 1740. Under his father's instruction, he received an excellent education for the times, and following a voyage in his youth, he began to study law in Portsmouth, New Hampshire. It was soon evident that he had great aptitude for his chosen profession. After being admitted to the bar, he settled in the town of Durham, in his native county. He purchased a homestead that continued to be his residence until his death. He was very successful in his law practice, and he found time to inaugurate several manufacturing enterprises that prospered. Thus passed about ten years of John Sullivan's early manhood, during which he accumulated a fair estate.

 Following the war, General Sullivan held many important offices in national and New Hampshire public life, and he died in his fifty-fifth year, the end being brought on prematurely as a result of exposure and hardships during the years of the Revolution and by the burden of responsibilities during an active and enviable career.

Notes

Chapter 6

15. Governor Samuel Cranston, in office 1698–1727.
16. For more on the Wanton family, see my book *Tiverton & Little Compton Rhode Island: Historic Tales of the Outer Plantations* (Charleston, SC: The History Press, 2012).

Chapter 7

17. At this early date, Fort George was named to honor King George.
18. The British attack on Lexington and Concord.
19. The *Rose*'s Captain Wallace learned it was Whipple who led the company that seized the revenue ship *Gaspee*. He wrote to Whipple: "You, Abraham Whipple, on the 10th of June, 1772, burned his Majesty's vessel, the *Gaspee*, and I will hang you at the yard-arm. James Wallace." Whipple replied with greater brevity, more wit and irony: "To Sir James Wallace, Sir: Always catch a man before you hang him. Abraham Whipple."
20. The Rhode Island General Assembly further voted and resolved "that the following officers be and are hereby appointed to command the vessels: largest vessel, Abraham Whipple, commander, with the rank and power of commodore of both vessels. John Grimes, first lieutenant; Benjamin Seabury, second lieutenant; William Bradford, of Providence, master; Ebenezer Flagg, quartermaster, at the wages of 4 pounds, lawful money, per month. Of the smallest vessel: Christopher Whipple, commander and William Rhodes, lieutenant."
21. In 1824, construction began on Fort Adams, which would become Newport's primary fort when the army garrisoned it in 1841. The new fort was so grand that it eclipsed Fort Wolcott in the minds of those who studied the defenses of Narragansett Bay, which contributed to Fort Wolcott's being forgotten within a couple generations.

Chapter 8

22. The State of Rhode Island removed the last remnants of Old Fort Dumplings in 1898.
23. Bishop George Berkeley, dean of Derry in Ireland, immigrated to the American colonies in 1729. His position as a minister of the Society for the Propagation of the Gospel in Foreign Parts brought him to the pulpit at Newport's Trinity Church.

Notes

24. This portion of the island does not lie within the boundaries of the city of Newport; for political reasons it was set off and is now the town of Middletown.

Chapter 9

25. The only reminder of Bristol's House of Industry is the road on which it was situated: Asylum Road, which is the entrance to the state's Colt Park.

Chapter 10

26. Metcalf Bowler, a wealthy and enterprising Newport merchant, bought a seventy-acre farm in Portsmouth and established his country seat there. Active in Rhode Island politics, he supported the Revolution and was a signer of the Rhode Island Renunciation of Allegiance. He served in the state General Assembly for nineteen years. He eventually became chief justice of the Rhode Island Supreme Court.

 In 1970, historians discovered that Bowler never gave up his loyalty to the king. To protect his estate, he placed himself under protection of the king's occupying troops, corresponding with General Sir Henry Clinton under the pseudonym Rusticus.

27. To make somebody or something appear rustic; to finish the outside wall with large blocks of masonry that are left with a rough surface, beveled and have deep joints between them.

Chapter 12

28. For more on lifesaving and lighthouses, see my book *Narragansett Bay: Postcard History Series*; (Charleston, SC: Arcadia Publishing, 2005).

Chapter 13

29. The word "colored" is used here because the original census report does not differentiate between black Africans, Native Americans, Asians or other people of color.

Bibliography

The text, photographs and illustrations for *Historic Tales of Colonial Rhode Island: Aquidneck Island and the Founding of the Ocean State* are from diverse sources, and every effort was made to identify those sources. Generally, text is derived from vintage and contemporary pamphlets, books, magazines and publications of the Rhode Island secretary of state. The authors of long sequences of directly quoted text are identified when known; usually, this text is in the public domain.

Amory, Thomas C. *The Siege of Newport, August, 1778.* Undated monograph detached from an unnamed volume, circa 1880.
Bacon, Edgar Mayhew. *Narragansett Bay.* New York: G.P. Pitman's Sons, 1904.
Chase, Mary Ellen, and the editors of *Look. Look at America New England.* Boston: Houghton Mifflin Co., 1947.
Gannon, Thomas. *Newport Mansions: The Gilded Age.* Little Compton, RI: Foremost Publishers, Inc., 1982.
Green, Welcome Arnold. *The Providence Plantations for 250 Years.* Providence, RI: J.A. & R.A. Reid, 1886.
Haley, John Williams. *George Washington and Rhode Island.* Commissioner of Education, State of Rhode Island, 1932.
———. *The Old Stone Bank History of Rhode Island.* Vol. IV. Providence, RI: Providence Institution for Savings, 1944.
Herreshoff, Grace. "The U.S. Naval Torpedo Station." *Harper's New Monthly Magazine* (1902).

Howe, M.A. DeWolf. *Who Lived Here?* Boston: Little, Brown and Company, 1952.

Lawton, Herbert A. *Historic Newport.* Newport, RI: Newport Chamber of Commerce, 1933.

Loiacono, Gabriel J. *Rhode Island Poorhouses.* Rhode Island Historical Society Publication, Summer 2007.

Millar, John Fitzhugh. "HMS *Rose.*" In *Rhode Island Yearbook*, no. 73. Riverside, RI: Rhode Island Yearbook Foundation, n.d.

———. *Rhode Island: Forgotten Leader of the Revolutionary Era.* Providence, RI: Providence Journal Company, 1975.

Munro, Wilfred H. *Picturesque Rhode Island.* Providence, RI: J.A. & R.A. Reid, 1881.

Panaggio, Leonard J. *Portrait of Newport.* Providence, RI: Mowbray Company, 1969.

Picturesque America, Part Sixteen. New York: D. Appleton & Co., circa 1890.

Preston, Howard Willis. *Rhode Island and the Sea.* Providence, RI: Office of the Secretary of State, 1932.

———. *Rhode Island's Historic Background.* Providence: Rhode Island Tercentenary Commission, 1936.

Sherman, Archibald C. *Newport and the Savings Bank.* Newport, RI: A. Hartley G. Ward, 1944.

United States Volunteer Life-Saving Corps in Rhode Island. Fourth Annual Report to the General Assembly. Providence, RI: E.L. Freeman Co., State Printers, 1909.

Wolter, Scott F. "Venus Alignments in the Newport Tower of Rhode Island." *Epigraphic Society Occasional Papers* 26, 26.1, 26.3 (2010).

About the Author

Richard V. Simpson is a native Rhode Islander who has always lived within walking distance of Narragansett Bay, first in the Edgewood section of Cranston and then in Bristol, where he has lived since 1960.

A graphic designer by trade, he worked in advertising, printing, display and textile design studios. He designed and built parade floats for Kaiser Aluminum's Bristol plant and the U.S. Navy in Newport, Rhode Island. After retiring in 1996 from a twenty-nine-year federal civil service career with the U.S. Navy Supply Center and Naval Undersea Warfare Center, he began a second career as an author of books on subjects of historical interest in Rhode Island's East Bay, with his principal focus on Bristol. This is his nineteenth published title.

The author in his Bristol study contemplates a future narrative.

About the Author

Richard and his wife, Irene, are antique dealers doing business as Bristol Art Exchange. They received their Rhode Island retail sales license in 1970.

Beginning in 1985, Richard acted as a contributing editor for the national monthly *Antiques & Collecting* magazine, in which eighty-five of his articles have appeared. He now writes freelance antiques articles for *Treasures* magazine.

Bristol's famous Independence Day celebration and parade was Richard's first venture in writing a major history narrative. His 1989 *Independence Day: How the Day Is Celebrated in Bristol, Rhode Island* is the singular authoritative book on the subject. His many anecdotal Fourth of July articles have appeared in the local *Bristol Phoenix* and the *Providence Journal*. His history of Bristol's Independence Day celebration is the source of a story in the July 1989 *Yankee* magazine and July 4, 2010 issue of *Parade* magazine.

OTHER BOOKS BY RICHARD V. SIMPSON

A History of the Italian-Roman Catholic Church in Bristol, RI (1967)
Independence Day: How the Day Is Celebrated in Bristol, RI (1989)
Old St. Mary's: Mother Church in Bristol, RI (1994)
Bristol, Rhode Island: In the Mount Hope Lands of King Philip (1996)
Portsmouth, Rhode Island, Pocasset: Ancestral Lands of the Narragansett (1997)
Tiverton and Little Compton, Rhode Island: Pocasset and Sakonnet (1997)
Bristol, Rhode Island: The Bristol Renaissance (1998)
Tiverton and Little Compton, Rhode Island: Volume II (1998)
America's Cup Yachts: The Rhode Island Connection (1999)
Building the Mosquito Fleet: U.S. Navy's First Torpedo Boats (2001)
Bristol: Montaup to Poppasquash (2002)
Bristol, Rhode Island: A Postcard History (2005)
Narragansett Bay: A Postcard History (2005)
Herreshoff Yachts: Seven Generations (2007)
Historic Bristol: Tales from an Old Rhode Island Seaport (2008)
The America's Cup: Trials and Triumphs (2010)
The Quest for the America's Cup: Sailing to Victory (2012)
Tiverton & Little Compton Rhode Island: Historic Tales of the Outer Plantations (2012)

Visit us at
www.historypress.net